# HEBER SPRINGS PORTRAITS

# HEBER SPRINGS PORTRAITS

CONTINUITY AND CHANGE IN THE WORLD DISFARMER PHOTOGRAPHED

TOBA PATO TUCKER

ESSAY BY ALAN TRACHTENBERG

UNIVERSITY OF NEW MEXICO PRESS · ALBUQUERQUE

Library of Congress Cataloging-in-Publication Data

Tucker, Toba Pato.

Heber Springs portraits : continuity and change in

the world Disfarmer photographed / Toba Pato Tucker ;

essay by Alan Trachtenberg. — 1st. ed.

p.   cm.

ISBN 0-8263-1733-2 (cl.).—ISBN 0-8263-1734-0 (pbk)

1. Portrait photography —Arkansas—Heber Springs.

2. Disfarmer, Mike, 1884–1959—Influence.

3. Disfarmer, Mike, 1884–1959. Disfarmer.

4. Heber Springs (Ark.)—Pictorial works.

5. Tucker, Toba Pato.   I. Title.

TR680.T83  1996

779'.2'092—dc20   95-50158

CIP

*Printed and bound in Korea by*

*Sung In Printing Company, Ltd.*

FOR MY DAUGHTER, DENA

# CONTENTS

I wish to thank the people of Heber Springs, Arkansas, for joining me in creating this memorable document, the result of my aspiration to photograph the people portrayed by Mike Disfarmer. To all those who allowed me to photograph them, whether or not their images appear in this book, I owe a debt of gratitude.

My portraits are a collaboration between the sitter and myself, the image reflecting our mutual consent and respect. To portray the residents of Heber Springs required the encouragement, commitment, and support of the people involved who worked with me toward a mutual goal, and for that I am sincerely grateful.

In Heber Springs, I enjoyed the warm friendship and generosity of Diane and Bill Johnston, who sustained me while I lived in their community and shared with me their insights into local customs and practices. Peter Miller's moral support and generosity of spirit were consistent and encouraging. And I want to thank Julia Scully for her gracious encouragement.

I also wish to thank Louie Clark and his daughter, Jeannie McGary, for the time they spent helping me to learn about the area's history; Joe Allbright for generously giving his time to recount stories regarding the salvaging of the negatives, and describing the old studio; Thurmon Bailey, with his unique personality, for showing me the town in a way I would not have seen by myself; Bessie Utley, for remembering Mike Disfarmer and telling me stories about him; and Everett Henson and Randy, for restoring my house and building the darkroom which was essential to the project. Greer Lile, whose guidance and advice regarding my vintage camera were invaluable, is a respected friend who deserves a special word of thanks and appreciation.

I felt privileged to have the opportunity of meeting Mike Disfarmer's family and wish to thank Harry Neukam and Louise and Roy Fricker for generously sharing their memories, family history books and albums, and for making the material available for use in this publication. Also I thank them for their confidence in me, and their warm hospitality.

I am honored that Alan Trachtenberg wrote the eloquent introduction to this book, continuing his contribution to interpreting America's visual history. I am glad that he found Mike Disfarmer as interesting as I did, and recognized his ability to record the people of Heber Springs so distinctively. My special appreciation to Helen A. Harrison for writing the preface to this book as well as for her continuing assistance in editing my efforts to write about my work, and for listening astutely and with insight to the experiences I recounted.

My thanks also go to Dana Asbury, my editor at the University of New Mexico Press, for her initial appreciation of the work, and for her sensitive treatment of it for publication.

Members of my family, friends, and fellow photographers were supportive throughout the Heber Springs project and thereby added to my achievements as a photographer. Thanks are due to my daughter, Dena, who is always there for me with understanding and advice; my sister, Linda Pato, for her devotion and faith in me; Harold Feinstein for instilling the love of photography at the beginning; Flavia Derossi Robinson, for her warm friendship, generosity, and endless kindness; Deborah Ann Light, for her encouragement and consistent interest in my achievements; Linda Hackett Munson, who always keeps me informed by mail about our mutual interests, no matter where I am; Russell Munson, who took me up in his yellow, single-engine Piper Super Cub to view the town from the sky when he and Linda visited me in Heber Springs; George Steeves, for sharing his vision, and for listening; Joyce and Robert Menschel, for their appreciation of my work and their support; Jill Rose for her understanding; S. L. Highleyman for his friendship and assistance; and especially Robert Giard, whose photographs I admire greatly, for a long friendship during which we have shared our portraitmaking experiences, and also our hopes and dreams.

In Arkansas, those who showed interest in the Heber Springs project include: Dale Carpenter, producer of *The Arkansas Traveler* AETN-TV; Townsend Wolfe, director of the Arkansas Art Center; C. Fred Williams, Ph.D., University of Arkansas, Little Rock; Calvin Dunham, Arkansas Tech University; and W. K. McNeil, Ph.D., director of the Ozark Folk Center.

I acknowledge with gratitude those organizations which generously supported the Heber Springs project: the Arkansas Humanities Council; the Arkansas Community Foundation; the Arkansas Arts Council; the Cleburne County Arts Council, Heber Springs; the Horace W. Goldsmith Foundation; the New York Foundation for the Arts; and Polaroid Corporation, Materials and Supplies Grant.

# TOBA TUCKER'S TRUTH

HELEN A. HARRISON

Toba Tucker modestly characterizes herself as a "documentary portrait photographer," a description that fails to encourage appreciation of her passionate commitment, sensitive insight, or subtle artistry. Although not visible, her presence inhabits her portraits, mediating our perceptions according to her covenant with the people she depicts. This downplaying of subjectivity is essential to Toba's strategy. Calling her work documentary makes it seem straightforward and honest, in the tradition of the photograph as a truthful record. Perhaps, but whose truth does it tell?

Not Disfarmer's, certainly. Although he lived and worked all his mature life among the people of Heber Springs, Disfarmer deliberately alienated himself from them. He often seems mercilessly frank, like the grumpy relative who enjoys finding fault. As a result, many of his portraits have a guarded quality, no doubt reflecting the formality of the occasion but also indicative of the psychological distance between photographer and sitter. Even the proudest of his subjects look strangely vulnerable—a quality they may not have recognized in their individual portraits but which runs as a consistent undercurrent through the stark studio images and surfaces when they are seen as a group.

Toba, on the other hand, was a genuine outsider who made a determined effort to open her mind and heart to the Heber Springs community. Rather than imposing her attitudes and preconceptions, she allowed her subjects an extraordinary latitude in self-presentation, encouraging them to guide her toward the truths they believed were appropriate to reveal. To return to the family metaphor, she was like the wise relative who counsels without contradicting, praises without flattering, and respects confidences. Thus her portraits are gifts, generously and willingly given by the subjects, gratefully accepted by the photographer, and turned over to the viewer with the tacit understanding that they should be treated with due respect.

Moreover, Toba always intended her images to complement each other in a way that Disfarmer's were not designed to do. While each portrait has a discrete character, the photographer's impulse to discover continuity within the community and among its generations influenced her choice of format, light-

ing, and other unifying factors. The serial approach is integral to Toba's aesthetic and suggests a closer kinship with predecessors such as August Sander and Roman Vishniac than with Disfarmer, whose work was not shown as a series until after his death.

In two important respects, however, Toba emulated Disfarmer's precedent: she adopted his camera and his studio setup, both of which were radical changes for her. But adjusting to the new camera—a challenge she describes eloquently later in this volume—was more than an acknowledgment of Disfarmer's stimulus. The change enabled or perhaps forced her to move beyond a place where she felt comfortable, where she knew what she could do and how she would do it. Both artistically and technically she took an enormous risk, one that paid off in the surpassing human insight and poetic dimension of her Heber Springs portraits.

Prior to this project, Toba never had a formal studio; she always went to her subjects. This time, she departed from her usual procedure by inviting them to come to her, forcing them to enter her territory. This was what Disfarmer had done, albeit in a downtown building instead of an isolated house overlooking a picturesque lake. But in both cases it was necessary for them to cross the threshold of an unfamiliar domain, one in which the photographer called the shots. This was far more of an issue for Toba than for Disfarmer because she approached her subjects rather than the other way around. They came to her not as paying customers but by invitation, to fulfill her intentions, not their own.

Without diminishing Disfarmer's achievement, I believe it is fair to say that whatever art we find in his work is a by-product of the commercial portraiture that was his livelihood, whereas Toba's primary concern, without consideration of financial reward, is the expression of her artistic intentions. That she cannot do this at the expense of her subjects' integrity is the reason that she—an invader, an interloper, an offcomer—earned the trust and affection reflected in their eyes.

Toba's truthfulness is therefore determined by two potentially conflicting forces. To balance her own aesthetic goals with her sitters' needs, she must get behind their faces without violating their sense of who they are and how they wish to be depicted. With sensitivity and patience, she has resolved this dichotomy to create images that penetrate without wounding, reveal without embarrassing, and sing their truths as duets between the portrayer and the portrayed.

HEBER SPRINGS PORTRAITS

# IMAGINING HEBER SPRINGS

A CONVERSATION

OF IMAGES

ALAN

TRACHTENBERG

You have to squint at the map to make out Heber Springs, Arkansas. It shows up as a spot in the north-central region of the state, about forty miles due north of Little Rock, on the edge of the Ozark Mountains. Another hundred and fifty miles or so in the same direction gets you to the Missouri border; to the east, Memphis and the Mississippi River lie about a hundred and fifty miles away.[1] The universal coordinates, 35.30 N by 92.02 W, confirm an exact location on earth. Small as it is (current population near 6,000), it's a real place, incorporated in 1881 as Sugar Loaf, after Sugar Loaf Mountain in whose valley it lies and whose several mineral springs gave the location a promising natural resource. As early as 1837 local landowners chartered a company with the aim of converting their remote springs into the profits of an "elegant watering place." Nothing happened until Max Frauenthal, an en-terprising German-Jewish merchant from Memphis, bought the site in 1881, set up a development company, and founded a town. The town boomed after a fashion in the 1890s and reached its stride when in 1908 a shortline rail-road, the Missouri and North Arkansas, brought visitors from far and wide in search of a fashionable spa with bubbling springs, pure air, and mountain scenery. The Frauenthal family took up residence and remained leading citi-zens. In 1910, to correct the anomoly of the post office having one name—Heber, after Dr. Heber Jones, son of the previous owner of the town-site—and the town another (there having been another Sugar Loaf post office elsewhere in the state), Heber Springs was adopted as the official name.[2]

The town's origins and early history as a rather upscale watering place in the Ozark foothills reveal that Heber Springs is not exactly a typical rural Southern village, not as isolated from the currents and amenities of modern life as its location on the map may lead us to expect. Elsewhere in Cleburne County independent farmers and a small number of tenant farmers eked out meager livings growing cotton on scrubby hills, but the town itself prospered in the wake of the railroad connection. Accommodations could be had at about fifteen hotels in the 1910s and 1920s; nine were still active in 1928. "Spacious two-story frame buildings with gingerbread trim and long covered

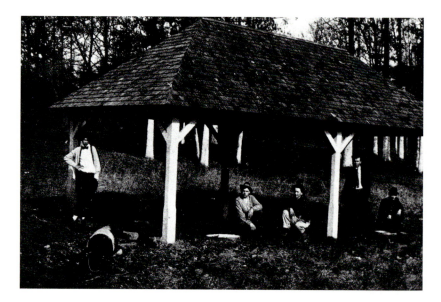

*Spring Park showing the springs, 1920s*

*Spring Park, 1990*

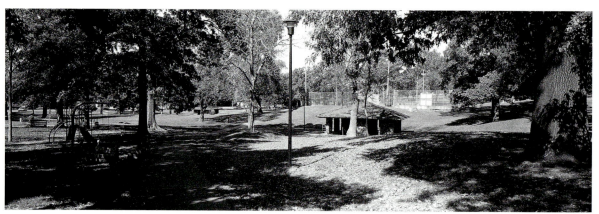

porches," writes a local historian, "housed families who came to spend the summer and drink the water."[3] Guests from Memphis and the Mississippi Delta took the waters and rocked away the hours on porches facing the town park. A woman born there in 1889 recalls "women bringing trunks with them full of long dresses and petticoats because that was the style of the day."[4] With its finished sidewalks Main Street offered a nightlife complete with two movie houses, one of them an open-air theatre, an ice-cream parlor, candy kitchen, dance pavilion, skating rink, and saloons ( before and after Prohibition; since 1943 the county has been legally "dry"). Stores and services included several millinery shops, general merchandise shops, a furniture store, a shoemaker ("boots and shoes made to order"), and several physicians and lawyers. Among the regular festivities were an Old Soldiers Reunion Day (still celebrated) and balloon ascensions.

The town had its good old days. Indeed, the county as a whole showed an increase in population after 1900.[5] But after a generation the high life faded; the mineral waters lost their fizz or people their taste for it, and so did the town. Hard times hit during the Depression of the 1930s, and the once-popular vacation spot shed its glamour and part of its population, listed as about 1,500 in 1941. The WPA American Guide Series volume on Arkansas in that year mentions mineral springs but makes it seem that a mural in the post office is the main attraction of Heber Springs; gravel roads and a one-way suspension bridge seem the main way into town.[6] On a recent roadmap it still seems embedded in a tangle of country roads. A scan of about a ten-mile radius picks up other names like Stark, Crossroads, Ida, Tumbling Shoals. To be sure, Heber Springs has a more conspicuous presence than these other dots on the map; a county seat, of Cleburne County, it qualifies for red print. And it's

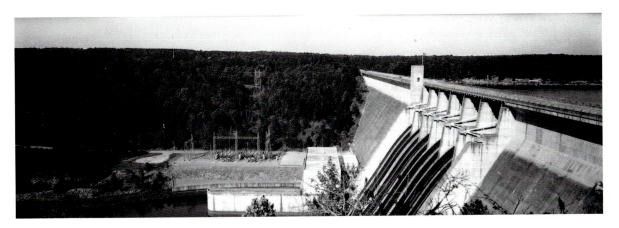

*Greers Ferry Dam, 1990*

surrounded by some half a dozen little red tent symbols which signify camping sites. In the early 1960s the US Army Corps of Engineers dammed up the nearby Little Red River, creating Greers Ferry Lake and a recreation region which stopped the town's slide and has restored the town's reputation for rest and play. Anyone on a highway nearby thirsting for greener scenery and a refreshing swim, or a place to retire or fish for trout, might be tempted by these cartographic inducements. There seems to be no easy way to get there—no interstate runs close enough to qualify as the obvious route, and no railroad any longer—but road map symbols make it seem worth a try.

It's safe to say that for most people the name Heber Springs is not even faintly familiar. Can anyone bring an image to mind? A county courthouse? A church steeple? A monument? Does the town have a look which distinguishes it from other out-of-the-way places? Is there anything to see which

*Mike Disfarmer, 1940s*
*Photo taken by Bessie Utley,*
*Disfarmer's assistant*

tells us that something ever happened of interest to outsiders, a history worth finding out about, a collection of stories to conjure images from? Or images to elicit stories from? History, place, and images are, after all, codependent in our age of instant visual communication. Since the birth of photography more than a hundred and fifty years ago, the popular sense of reality itself has increasingly counted on images to which we can point for solid reference, for assurance that something solid exists or once did. Can we say that a name inscribed on a map stands for a body, if there are no images to prove it? It's a paradox peculiar to our times that without the visual references endowed by photographs, Heber Springs or any unfamiliar site corresponding to a dot and a name on a map remains unreal, unthinkable, something beyond the horizon of knowability.

The case of Heber Springs confirms the point in a particularly striking way. For significant photographs were in fact made there about fifty years ago. That's why the name rings a bell and excites curiosity. And now there are additional or supplemental photographs, recent images made explicitly in light of the earlier images. The site of a unique conjunction of photographic projects and visions, Heber Springs now comes to life beyond its local precincts. The photographs made at Heber Springs in the 1940s by Mike Meyer, a.k.a. Mike Disfarmer, and in the 1990s by Toba Tucker, together compose a world of striking contrast, of photographic methods and intentions as much as of subjects. Found and published less than twenty years ago, the Disfarmer pictures are startling experiences; their subjects come out to us with the vividness and clarity of unaltered reality itself. Or as if they stepped off the pages of tales of small-town America as imagined by E. B. Howe, Sherwood Anderson, and Eudora Welty, chronicles of lives hammered by provincial narrowness and ignorance into a sinewy kind of endurance tempered with sly humor. Many seem like Anderson's "grotesques," twisted apples with a bitter yet pungent flavor. We must wonder at the art and craft and purpose which produced such a gallery of provincial characters unforgettable in their intense inwardness and vulnerability. Depicting many of the same subjects grown older, more settled into comfortable lives, Tucker's pictures are quite different, more subdued, less gritty, less etched with the urgency which gives the Disfarmer pictures their aura of inscrutable drama.

Taken together, these two quite distinct yet apposite groups of pictures create a substance, a body, a reality which compels attention. Yet it is not a reality easily explicated. The place compels us precisely to the degree that these pictures mutually put questions about the town, the moment, the people,

and the photographers themselves, queries at once too exacting and too in-definite for easy answers. As a photographic event, a construction of camera work, Heber Springs lays claim to a place in the American imagination by virtue of the mysteries it projects and the perplexities it arouses. Like the red ink on the road map the pictures draw us into a shadow world whose center is fixed by the lens of a camera and the coordinates it projects upon a plane of vision.

Mike Meyer, town photographer at Heber Springs for some forty years until his death in 1959, became known to a wider world with the publication in 1976 of a finely produced book called *Disfarmer: The Heber Springs Portraits 1939–1946*.[7] The name, the book, the story of his death as a recluse and of the fortuitous survival of his plates and prints, all play a part in the perplexities, the unanswered questions, which hang over his pictures. Why did he portray his people as he did, set in a shallow space against a plain black or white back-drop, flooded in natural light? Did he have any sense of a social, a documen-tary, a moral, or an aesthetic purpose? Are his pictures interpretations of a so-ciety and a culture, visions in which hidden meanings might be read? Did he have posterity in mind, or just the immediate wants and needs of his cus-tomers, or his own driving need to get the look of people down in black and white? Meyer left behind no documents or personal artifacts, only about three thousand glass plates (which he continued to use long after they had become obsolete), some personal papers, scores of memories among his townspeople of his studio, his way of working, and his eccentricities. There are several pho-tographs of his extraordinary studio made before its demolition after his death. A vague biographical profile can been pieced together from these and other public sources, but the man remains a mystery, an entry in the history of the American arcane. The uncanny aliveness of the surviving pictures compounds the enigma.

The sense of immediacy in his portraits, of an astonishing clarity coexist-ing with an ambiguous covertness, something hidden (is it the photogra-pher's scorn?) within what is so glowingly shown, is part of what drew Toba Tucker toward Heber Springs in 1989 to see the place and its inhabitants for herself. The Disfarmer portraits had inspired her since she first saw them on exhibition in New York in 1977. Her work had taken her chiefly to Indian communities of Navajo, Montauk, and Shinnecock peoples, drawn by the drama of people undergoing radical change. It was while returning in her van from Colorado in 1987 that she felt herself pulled irresistibly toward Dis-farmer's home town. She eventually set up shop and stayed for two years,

digging deeper into the life of the town, listening to stories of the older folks, seeking out the newcomers, tape-recording everywhere, and photographing the people in her own distinct way. She found many who had sat for Meyer as children or young adults, and included people who had settled there since the region's reversal of fortune, the opening of the Greers Ferry Lake recreational area in 1963. (Since 1960 the area has increased its population by more than 60 percent.[8]) Many of the old Disfarmer faces have worn well through the years, and younger inhabitants have a stylish contemporary look. Change seems to have favored Heber Springs, bringing something of a cosmopolitan touch, probably on the wings of glamour magazines and television stars. How would Disfarmer have shown these youngsters, so much cooler than back then, all primped up for the prom? "I did not strive to emulate Disfarmer," she writes, "but brought my own personal vision to the project; my photographs are an extension of his portraits, not a recreation."[9]

Toba Tucker thought of her residence and work at Heber Springs as a continuing dialogue with Disfarmer, extending the implications of his portraits by creating a new context in which they might be seen anew, seen more clearly as historical documents, not just uniquely stunning images. The 1930s and 1940s, the period of Disfarmer's published pictures, brought sharp change throughout the country, nowhere more sharp and dislocating than in the rural South. Depression and world war posed severe challenges, the pinch of a stingy economy, the pain of separation. Sensing in Disfarmer's pictures "the community's strength in the face of those challenges," Tucker set about to explore responses to more recent changes of a happier but still ambiguous kind, the influx of retirees and of younger, more energetic business and professional people, a rising level of education and of abundance, an improvement in morale. Tourism and the recreation industry lie at the base of this upsurge.

In a way Heber Springs seems to be reliving its early boom days as a spa, when Mike Meyer began his career as town photographer. The symmetry between the challenges of the 1940s and the 1990s is not exact, but in both cases a camera has been present to record human traces of a social process. How effectively can the camera perform this task, in Tucker's words, of "recording cultural change"? Is it a reliable witness? Not just in the sense of fundamental honesty, but how much can the camera actually reveal about what is not there within the frame? Tucker's project of engaging Disfarmer's portraits in a dialogue with her own, the historical experience of the community as the issue at stake, boldly confronts these enduring questions about the medium.

At the heart of this story of Heber Springs is a story of photography itself, photography as an instrument and a mode of historical awareness. It's a story which tests the powers of the medium, brings us to the edge of the medium's great descriptive powers, the illusion it creates of time stopped and reality standing forth. Photography invites the muse of history only if we learn from its images what questions to ask about that illusory reality it seems so effortlessly to transcribe.

The story centers on the enigmatic figure of Disfarmer and his portraits at once so transparent and so opaque, so vivid and so inscrutable. The pictures in the 1976 book, the sixty or so selected from about three thousand surviving plates, cover seven years out of a career which spanned more than forty years. Putting aside the unanswerable question about the work which disappeared, and assuming that the published book provides a representative sample of the remaining available images, what might we deduce or surmise about a Disfarmer vision? The vision seems at first of a piece with familiar images of southern communities in the Depression years of the 1930s. Haven't we seen faces and bodies like these before, in sharecropper pictures by Walker Evans, Ben Shahn, Margaret Bourke-White: lean, wiry arms, haggard faces, well-worn work clothes? It takes another, more attentive look to see through that resemblance. A truer analogy appears in the famous "Studio" window of Walker Evans's "Penny Picture Display, Savannah, 1936," where we see the faces of white rural America scrubbed and prepared with smiles or glaring scowls for a quick machine-made picture to share with family or friends or lovers: not pictures of poverty or hard, unrewarding labor, but pictures of people pleased to be having their pictures made, and paying for that pleasure.

Disfarmer's work lies closer to these rapidly made mementoes of an instant's performance. The performances he records are more elaborate and complex but of an analagous sort. Singly, together with friends or lovers or family, dressed for a ballgame or a ball, standing or sitting, his subjects may have crumpled clothes, wear their hats indoors, have rough hands and heavy shoes. But they've washed their faces and combed their hair (even under their hats), and have probably tested out their look in a mirror. And Disfarmer depicts them as they are. He doesn't require that they deposit their everyday selves at the door. They present themselves masked only in the faces they know to be themselves; they are, in Auqust Sander's great words, people without masks. Most of the faces are eager to be seen, to impress themselves upon the plate; very few show lines of habitual reflection or introspection. These

folk live in their bodies, their faces, hands, arms, torsos, legs. Physical energy charges virtually every image from edge to edge. We feel how close to the surface lay erotic attraction and sensuous emotion in this highland community. Without guile or embarrassment the people casually touch themselves and each other; they have their being in their connectedness. Walt Whitman would have felt at home in the meaty democracy of Disfarmer's world. Like the poet, Disfarmer seems utterly accepting of their style of sociality and decorum. It may also be his own. Or it may be what he lacks and misses, something he desires sorely and thus self-protectingly views from an imper-

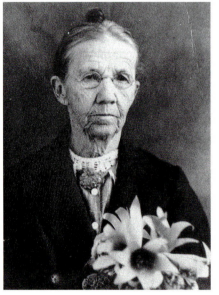

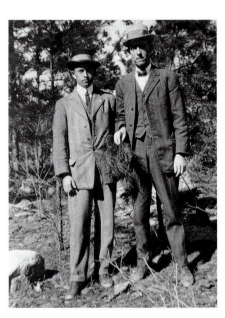

... Martin Meyer wore the blue in the Civil War, serving for his native state of Indiana. He received a pension for disability incurred from illnesses he suffered in Kentucky in 1865. He was the great grandfather of Dan E. Harder, World War I veteran for whom the Stuttgart American Legion Post is named. He died in 1898 on farm

*(left) Disfarmer's father, Martin Meyer, in his Union Army uniform, 1860s*

*(center) Disfarmer's mother, Margretha Weidenhammer Meyer, 1920s*

*(right) Disfarmer (on the right) and his brother*

sonal, perhaps scornful distance. But he does not make them feel like manikins or specimens. His subjects don't see themselves in the eyes of a government photographer or a journalist from New York, but of a local fellow, a Main Street dealer in self-images. How he manages the terribly mundane event of taking his studio pictures, what he invests in them of his own needs and urgencies, what of his own pleasure (the pleasure of scorn and hatred, perhaps, deflecting a secret love) resides in the pictures as a residue of the occasion: all this contributes to the patterns which form his acutely original vision.

The vision lies within and informs his pictures, but information about the man and his methods offer leads and provocations. Biographical details are sketchy, perhaps because his life itself lacked many of the outward elements which attend a public figure: born in 1884 (perhaps 1882) to German-Americans in Indiana, his father a Civil War veteran; moved with the family in

1892 to the German community of Stuttgart, Arkansas, and father took up rice farming; father died in 1898; moved with mother and siblings to Heber Springs in 1914; soon afterwards in partnership with another local photographer; lives with mother until her house is destroyed by a tornado in 1926; builds his own studio with living quarters shortly thereafter; mother dies in 1935; legally changes his name in 1939. He seems to have made the news only twice, at his death in 1959, which garnered him three inches in the local paper, and at what can only be called a premature, self-proclaimed rebirth twenty years earlier.

Everything we need to know about the photographer may well reside in the story of his change of name, one of the more perverse acts of self-renaming on record. "Truth is stranger than fiction," the newspaper account reads

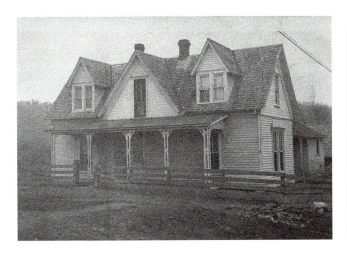 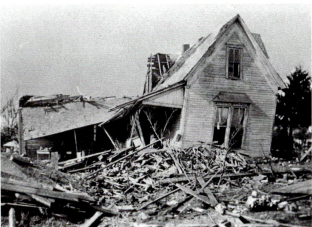

in words which ring as true for his pictures as for the fiction Mike Meyer produced in the guise of Mike Disfarmer, the fiction of that invented character enclosing the strange truth of the photographer. The occasion of the article was Meyer's successful petition in 1939, at age fifty-six, for his legal renaming. The strangeness lies in the utterly implausible reason given in his petition, a reason fantastic enough to qualify as mythic in proportion. The point was not so much to take a new name but to repudiate the old one. He was not "really" Mike Meyer, but some other nameless creature who at age three had been blown by a tornado from his birthplace in Portersville, Indiana, to the home of the Meyers several miles away. The family all knew this, he said, were embarrassed and humiliated by the stranger in their midst, and threatened to disown him. He would save them further vexation and fear by simply changing his name. "Many years of pondering and meditations," his petition reads,

*(left) The Disfarmer house in Heber Springs, 1920s*

*(right) The Disfarmer house in Heber Springs after the 1926 tornado*

11

have lead him to this decision.[10] And "Disfarmer?" The petition does not explain but the newspaper article does: "Since 'meyer' means 'farmer' in German, and since the petitioner was not a farmer, he chanced upon the name 'Disfarmer.' 'Dis' is said to mean 'not' in German."[11]

There seems a wily playing of the fool here for purposes too devious to grasp. Remembering "Meier" as an obsolete German word for "tenant farmer," for lowly peasant, Meyer archly insinuates his superiority to the town, his sophistication against their backward ignorance. The foundling tale and the new name at once deny his origins as the son of a peasant and proclaim his true identity as someone too obscure to be understood as by his townfolk, townfolk of his only by the sheer accident of how the wind blows. Did some inexplicable self-loathing lie at the heart of this game? The coincidence of the move from his mother's house after the tornado and the petition for the long-pondered change of name shortly after her death can hardly be happenstance. Echoing *The Wizard of Oz* (the film appeared in 1939), folklore about tornados, foundlings, changelings, and elements of voodoo, the story in its strangeness claims a certain grandeur of elemental myth. An extraordinary letter to his nephew, addressed "Dear Foster Nephew," about a year after his mother's death, gives an even richer tale, including an "old Man" who tells him and two relatives "that we were not all blood and that I was either Charles Cave or Charles August Cudahy but that I didnt [*sic*] know it." It includes a "Real Uncle Mike Meyer," who "blew away in the same storm that I came in," whose remains were found nine years later. Meyer's passion overrides punctuation in a rush to get this down: "this was in the year 1894 then about all his remains were just a little piece of his dress, little pieces of bones and altogather [*sic*] weighed about one ounce." Someone gives his mother "a little bundle" and she "called it her little Mike and huged [*sic*] it and wept." She put the bundle in a big doll and "Then played with it and huged [*sic*] and loved it and called it her little Mike, It had been planed [*sic*] that this bundle would be Buried with your Grandmother [Meyer's mother] but they had kept me in the dark about what this Bundle was and when your Grandmothers [*sic*] belonging was moved from Heber I Burned it up not knowing what it was and threw the Ashes into the Ditch in front of my Studio."[12]

Did Meyer expect anyone to believe a tale as tall and fantastic as this? Did he believe it? "Now I will tell you where the last known place is where your real Uncle Mike is, It is somewhere between the Gulf of Mexico and the Ditch In front of My studio here at Heber."[13] Yet he continued to visit his kin; a brother, two sisters, and children of his deceased Meyer siblings appear as heirs in a probate court petition after his death, and other relatives

12

remember him kindly and with respect, dismissing his changeling tale as a hoax.[14] Motives for such a yarn, such a grand fiction of self-remaking, lie beyond all surmise. They belong to the realm of folklore and magic and to the shadier pyschic recesses of the Ozark hills during the travail of the Great Depression.

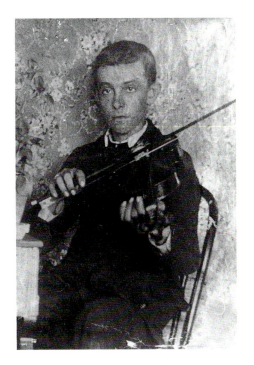

Like a Sherwood Anderson grotesque himself, Meyer insisted on his difference and embodied it as a name: Disfarmer, an allegory of what he is not. In the town Disfarmer was known and tolerated as a "character." He sometimes embellished the story to say he was blown all the way from Germany. Memories gathered by researchers recall a man who stood apart, kept to himself, never married or courted, could be kind and rude, disdainful and generous, often disheveled, yet sometimes he sported a beard, long hair, Prince Albert coat, and black hat.[15] This hint of the dandy, the bohemian bon-vivant, inside an exterior which grew increasingly gruff and unkempt, is a telling detail. It goes along with stories of his passion for fiddle-playing, for hours alone with a friend in his studio fiddling and strumming through the dizzying phrases of break-downs.[16] A village Dionysius, contemptuous of the Bible and absent at church, "an infidel" to his neighbors yet tolerated and welcomed at the occasional Mason meeting he attended, Meyer is remembered as someone who would never "try to 'make' a girl," and by a woman who worked as his assistant in the 1940s, as "a perfect gentleman" who "couldn't keep his hands off me."[17] Tricks of memory may account for the discrepancies, but the image of a paradoxical fellow rings true. The former assistant, Bessie Utley, recalls:

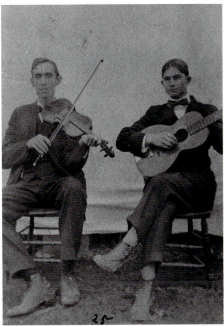

> Mr. Disfarmer was a person that nobody would never understand if they lived to be a million years old. You know, he would make fun of the people that would come in there. He didn't exactly make fun of them, but it was like he had a brain and like we never had—[and] I think he did. But, by acting like he did, it made the people kind of think he was nutty, which I knew he wasn't. They were afraid of him, yet they'd go there by the dozens.[18]

*(above) Young Disfarmer*

*(below) Disfarmer (left) and his cousin, Harry Neukam*

Puzzlement mixes with affection in these small-town memories, a kind of quizzical awe reserved for one of your own who is just a bit odd and forbidding. And after all, since 1976 Mike Disfarmer has brought honor to the town.

Disfarmer is the name of the difference Meyer felt from the town, a persona, a masked role to be performed—his way, in short, of remaining part of the town while standing apart in disdain. Was it analogous to the distance, the detachment, the necessary impersonality of standing behind the camera

rather than in front of it, the one who sees rather than the one on display? Julia Scully very helpfully suggests as much: "Perhaps it was his perception of his own alienation from his environment that permitted Disfarmer the artistic distance needed to record these plain country people so clearly."[19] It's the people who stand vulnerable in their guilelessness, not the photographer, hidden behind his camera mounted in a partition. The man who salvaged the surviving plates before the studio building was demolished in 1961, Joe Allbright, believes there was a window in that partition through which the photographer could check on his subjects. In the studio Meyer dominated as

*Disfarmer studio, Heber Springs*
*All three photos by Greer Lile,*
*1961*

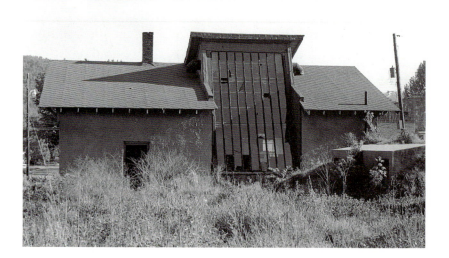

sovereign, free to remake people into revelatory images as freely as he remade himself into Disfarmer. He possessed the magic, and his pictures reflect the spell he cast.

The place the pictures were made, where they take place, was ruled by a regimen of need and desire and a discipline of obedience enforced by the photographer. In the pictures the space of the sitting appears without any special characteristics, a space without qualities, without physical depth or dimension, flattened to leave just enough room for people to sit on a plain wooden bench or stool or stand for their pictures. The common word for such a place is studio, though studio is more metaphor than description, a term long ago attached to the room where one goes to have a camera-likeness made, with the idea foremost that such a space is something like where one goes to have a picture painted. "Studio" gives the photographer's place an

14

inflated importance, and ambitious photographers from early on often played their parts as *artistes,* making a fuss over their "sitters" as if a work of art, a *portrait,* were in the offing. The rooms were often decked out as plush Victorian parlors or theatrical stages or anyplace other than what they really were: a photographer's workplace.

What is revealed in the Disfarmer pictures is an utterly vernacular place, not a parlor and nor are its occupants conventional "sitters" composing them-selves into ideal images. Remaining a workplace (the darkroom lay behind the camera), it was an antistudio, a studied denial of the falsehoods and fictions

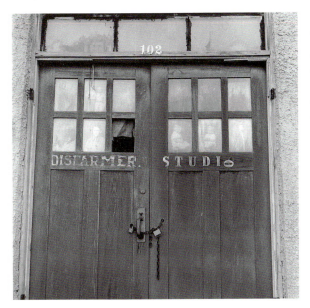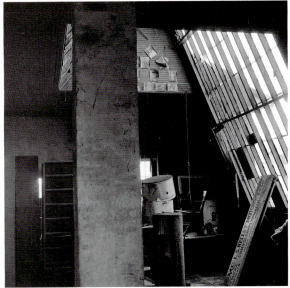

of conventionality for the sake of a fiction of another order. The design seems to have been to bring the subjects as flush with the discerning eye of the cam-era as possible, to overcome the distance of conventional poses and props in order to reveal a more essential, intransigent difference between the photog-rapher's eye and its object. Something fundamentally utilitarian governs the Disfarmer place. A starkly rectangular one-story stucco building with a hipped shingled roof, this twenty-by-thirty-foot structure on a double lot on Main Street across from the post office might have resembled a bungalow or shed except for its most striking feature: an oversized dormer window rising diag-onally on the northern wall from near the ground to several feet above the roof. After Disfarmer's death a local businessman bought the double lot from the deceased's estate (which was administered by the local bank). He sold it to another entrepreneur who in 1961 cleared away the studio to make room for a parking lot for the Piggly Wiggly store he put on the other half of the lot.

A pity the studio no longer stands. In photographs before the demolition the abandoned building with its rising skylight remains a source of amazement. The window slants inward at what seems a 60-degree angle, like a huge gash through roof and wall. About eight feet wide and fifteen feet tall, the oversized window consists of seventy-two separate panes. With its vertical mullions on the outside and horizontal crossbars inside, the giant glass wall projects the look of a factory, as if some serious business were going on inside, something requiring a flood of clear, even light. It is not known just where Mike Meyer got the plans for this machine-like enclosure for his business of making pictures; it is an adaptation of the "single-slant" design for studio lighting easily available in photographic handbooks or encyclopedias.[20] He built it in the late 1920s, after the tornado blasted his mother's house. We see it in a photograph made just outside the building in 1933; the words "The Meyer Studio" in nailed block letters (another industrial-style touch) appear on the garage-like double door with latch handle which serves as entrance to the studio. The plank doors are topped with six mullioned panes, each holding a photograph, samples of the work produced within the doors. In the predemolition images "Disfarmer." appears in place of "The Meyer" on the right-hand door; that odd placement of a period says plainly that Disfarmer was a name in its own right, not just the name of a studio.

Did something essential change in his photographs when "The Meyer Studio" gave way to "Disfarmer. Studio"? Impossible to say without evidence. There is one fugitive trace which may shed light on the question. Meyer had begun in Heber Springs as partner of someone named Penrose; a 1915 photograph of Main Street shows a sign, "Penrose and Meyer, Kodak Finishing," over a doorway that's part of the Jackson Theatre, a surprisingly posh picture house with 200–300 seats which sometimes offered opera by visiting troupes.[21] Flanked by tall white Ionian columns supporting an elaborate four-tiered cornice (a pattern repeated in the central arched doorway), the sparkling neoclassical brick building proclaims the cultural aspirations (aspirations for "culture") of the town in that booming era.[22] A surviving product of the Penrose and Meyer partnership, dated August 6, 1926, and stamped with their names on the verso, is a postcard picture of two women composed into a familiar studio design; one is seated at a table spread with a cloth; her right hand cups the base of a vase of flowers; her companion stands behind the table, her left hand touching the other's right elbow. A conventionally sweet studio ensemble, it's the sort of picture one might well expect from a studio housed in the Jackson Theatre, the gem of Main Steet destroyed a few years later by fire.

16

No such props or theatrical poses or strained composition, no interference or intervention by an idea of how subjects of photographs should look, appear in the Disfarmer pictures of 1939–46. Customers entered the garage-like door on the side of the building, arrayed themselves before either a black curtain or a white wall in a sitting area at right angles to the northern light of the giant window. Light falls from their right, depositing shadow on the left side of their faces. Side lighting was apparently all he relied on, no reflectors, no diffusers, no hot lamps. He worked with equipment some might think crude: hand-made cameras, glass plates, probably orthochromatic (insensitive to reds and yellows which thus appear dark in the prints). He persisted with the slower dry plates instead of celluloid film probably because that's what he learned to use, and why change? He seems to have used a 5 x 7 and a $3^1/_2$ x $5^1/_2$ postcard format, perhaps on the same camera. A twelve-inch lens, a Tessar made by Bausch and Lomb mounted on a Wollensak Betax #5 shutter, and a shorter Wollensak Double Anistigmatic #6, were among his surviving equipment. Subject-to-lens distances inferred from the 1939–46 pictures suggest that he used mainly the long lens for its superior modelling effects, probably at a fairly large aperture opening and slow speed, perhaps $1/_{25}$th of a second. Motion of a hand or head occasionally registers in his prints.

Disfarmer's apparatus, the long lens and the sidelighting, create a mirage-like illusion of reality; you can almost hear his subjects breathing. He apparently used no filters, allowing sunburned flesh to look even darker, and freckles darker yet. The effect is sculptural and cinematic, resembling the breath-taking hyperrealism of 32mm silent black-and-white movies. Against the black background his people leap out; nothing distracts attention from them, from the physical details which make their bodies and dress and postures and expression such amazing vehicles of inner life: the delicacy of a hand touching a shoulder, the twist of an ankle, the tilt of a hat, the rumpled folds of trousers, the fall of cotton dresses on the work-stiffened bodies of country women. This is the sort of spontaneous, gestural reality few studio photographers in cities or towns would tolerate; contemporary filmmakers try to fabricate that look but usually miss. Disfarmer knew how to fill his frame. He didn't say much as he worked, made no effort to change the angle of a head or to elicit a smile, but barked out an order now and then to move here or there. He worked by instinct, knowing what was right for a photograph. He knew how to make the edges of his frame vibrate with the presence of his subjects. The group portraits offer panormas of individuals crowded together on a bench or standing shoulder to shoulder with such unself-consciousness and openness to the camera that one might gaze and gaze and never reach the end

of wonder. Disfarmer tapped some fundamental vein of art, the sheer inexplicable and depthless pleasure of imitation. The subjects play their part, but Disfarmer created the space and the conditions for their games of self-presentation. He knew how to do his job. We can only guess with what mixture of precision and passion he performed his part under the dark cloth.

Was it contempt for his clients, scorn of their ignorance, hatred of their self-sufficiency, the cherished secret of his superiority, perhaps a deeper secret of lust for their recognition and affection, which released in Mike Meyer Disfarmer the powers of art? In an art of such impersonality and detachment it is astonishing how much the hidden figure of the artist leaves his mark, makes his enigmatic presence felt. Yet it is the characters he gives us to know who initially attack our own defenses, who tempts us to translate appearances into words, to infer states of mind or life stories from what we see. The pictures, like shards of time, ultimately resist such translation, but general features might be described. We see signs of hard work, of strength and endurance, of caring for each other and for young children. People appear in their work clothes, farmers in bib overalls, mechanics, sales clerks, waitresses, truck drivers, soldiers, perhaps school teachers. The range of social class is not wide; the upper crust of the town seemed to avoid the plebeian shop, probably preferring the panache of a city studio. Thus the sense of an egalitarian community here, a bondedness among those portrayed. All white, of course, and probably all Anglo-Saxon Christian, possibly a nonbeliever here and there, the community imagined in Disfarmer's studio presents a disarming look of homogeneity. At the same time it presents stunning studies of individuality. Whatever his sitters may have thought or feared of Disfarmer's eccentricity, they trustingly gave themselves over to him, as if he were, in spite of himself, one of them. It's what they called nutty even as they surrendered to it that makes Mike Meyer a.k.a. Disfarmer so compelling an American artist, an autochthonous genius of vernacular portrait photography: an original if grotesque native artist of the camera. Time and place come into a focus in his prints simply dazzling to behold.

Lavishly detailed faces and bodies linked to time and place by the knowledge we have that many of the 1939–46 pictures had wartime needs behind them, and similar in look, at least superficially, to the great FSA record of ravaged human hopes in the rural South in the 1930s, the Disfarmer pictures seem to fall with ease into the category of social documents. So they are, but not in any of the commonplace ways. Placed next to information about the depressed rural economy of Cleburne County and the deflation of the Heber Springs mineral-water bubble, the pictures seem accurate expressions of a com-

18

munity's fortitude, the resources of personal and communal culture in a place which must have felt itself abandoned by a cruel fate, as did many rural places in the 1930s. These are the faces and bodies of people who live with the fear of tornados. Memories gathered by Julia Scully and more fulsomely by Toba Tucker, and Tucker's own portraits of the Heber Springs world as it looks and knows itself today, provide yet another enhancement of the social and historical aspects of the Disfarmer pictures. Each of the circles we draw around those images teases out further implications, give his people and their community a fuller, more palpable reality. We learn to see traces of hard work in thin soil, a communal life centered in the church (mainly Baptist) which valued family life as well as neatness, the emotions of women and children as they stand before the camera imagining their husbands and fathers and lovers at some inconceivable place overseas gazing on the resulting picture. From the literal documentary evidence alone we can reconstruct a historical world continuous, through change, with the world depicted in Toba Tucker's similarly open and accommodating pictures, perhaps more gentle than Disfarmer's but made in a similar spirit of acceptance.

In their separate ways the Disfarmer and the Tucker images are strong pictures of strong, vivid, magnetically intriguing people. Their lives reside in their faces, their appearances. But even while bespeaking time and place, they do so as distinct individuals, each untranslatable in his or her distinctiveness, each performing the communal ethos in an individual way. Disfarmer so profoundly captures the normalcy of life in his place because he understands it from within its deepest psychoses. We are mistaken to think that documentation battles with art in these pictures. A distillation of an acerbic, perhaps tragic view of life with something quirky, homespun, and deeply intuitive, it's the art of Disfarmer which puts him in touch with time and place, which gives his portraits their power as singular documents. A residue of the Disfarmer uncanniness clings to the images by Tucker of the same people at a later stage of life and culture. Though the lighting is different and the edges less taut with some obscure energy, her picture of the three young girls, granddaughters and great-granddaughter of original Disfarmer subjects, evokes the old studio and its collaborative performances of self-portrayal. So do her close images, in which we feel distance between camera and subject on the verge of dissolving into a mutual touch. It's the Disfarmer residue and aura, the continuing appeal of the inscrutable in his images and its refraction in Tucker's pictures, which makes this conversation of images in Heber Springs a discourse at once hypnotic and instructive.

I want to expess my gratitude to Toba Tucker for graciously sharing her notes and impressions of Heber Springs and kindly supplying answers to many queries. My thanks also to Diane Johnston of Heber Springs for her generosity in allowing me to intrude on her time with several small inquiries. Conversations with Jerry Liebling and William N. Parker proved invaluable in helping me clarify my thoughts about Disfarmer.

## NOTES

1. Information throughout about Heber Springs and Cleburne County is gleaned from Evalena Berry, *Time and the River* (Little Rock, Ark.: Rose Publishing Co., 1982) and *Sugar Loaf Springs: Heber's Elegant Watering Place* (Conway, Ark.: River Road Press, 1985).

2. Berry, *Time and the River,* p. 190.

3. Ibid.

4. Gerald T. Hanson and Carl H. Moneyon, *Historical Atlas of Arkansas* (Norman: University of Oklahoma Press, 1989), p. 60.

5. *Arkansas: A Guide to the State* (New York: Hastings House, 1941), p. 273.

6. Julia Scully, *Disfarmer: The Heber Springs Portraits 1939–1946* (Danbury, N.H.: Addison House, 1976).

7. Ibid., p. 66.

8. Toba Tucker, personal statement.

9. "In the Matter of the Change of Name of Mike Meyer to Mike Disfarmer," Circuit Court Record, Cleburne County, Arkansas, March 20, 1939.

10. *Heber Springs Times,* April 13, 1939.

11. Mike Meyer to Harry Neukam, Sr., January 29, 1936.

12. Ibid.

13. "In the Matter of the Change of Name. . . ."

14. Julia Scully, "Mike Disfarmer, Heber Springs, Arkansas," *Aperture* 78 (1977): 8.

15. Ibid.

16. Scully, *Disfarmer,* pp. 3–4.

17. Ibid., p. 5.

18. Ibid., p. 12.

19. For example, see Bernard Edward Jones, ed., *Cassell's Encylclopedia of Photography* (London and New York: Cassell, 1911), pp. 526–28.

20. Berry, *Sugar Loaf Springs,* p. 47.

21. Photograph in Berry, *Time and the River,* p. 324.

# CONTINUITY AND CHANGE

TOBA PATO TUCKER

In 1977, at the time I decided to become a portrait photographer, I saw a remarkable exhibition at the International Center of Photography in New York City. It was Mike Disfarmer's portraits of people in Heber Springs, Arkansas. I went back again and again to look at the portraits, drawn by the strength of the people's faces, never dreaming I would one day be living in Heber Springs and photographing some of these same people.

The people whose portraits I saw in the exhibition, and studied over and over again in the book that accompanied it, intrigued me for reasons that still endure: the raw honesty I could see in their eyes and faces, the hard work evidenced by their calloused hands, the nostalgia provoked by their clothes, which made me speculate about what role they played in Heber Springs life, the way they sat or stood, and the way they held each other, or didn't. They came to the camera with confidence, presenting themselves as the best of who they were. They may have worn their "coming to town on Saturday" clothes, but there were no inner contrivances—their strength of character and dignity were intact.

And I am still drawn in because I believe that Mike Disfarmer was similarly unaffected when he snapped the shutter of his vintage camera containing his outmoded film stock. It was the only way he knew. He was spiritually connected to the subjects of his portraits, in spite of his well-known statements to the contrary. As though to ensure his isolation, he took pains to distance himself from them and his family by changing his name and inventing a story of such emotional complexity and imagination it could only provoke sympathy. But although collaboration, the essence of a portrait, prevailed in spite of his efforts, one wonders whether he would have made different pictures, even "better" ones, if he had liked his subjects.

Disfarmer's distinctive portrayal of these rural people, in a particular place and time, interested me and stirred my imagination, emotions, and innate artistic sensibility. It wasn't enough for me to just look at the pictures. I wanted to know who these people were, and what their lives were like after they left Disfarmer's studio—after they stopped for that fraction of a second

21

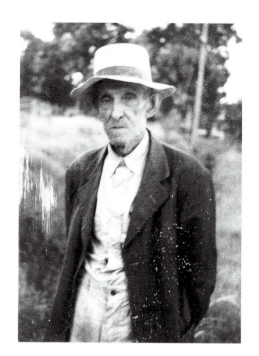

*Last known photograph of Mike
Disfarmer, 1958
(He died in September 1959.)*

for the camera to record their personae. I wanted to talk to them. What did they talk about, what did their voices sound like, why did they have their photographs made? What were their lives really like? And, ultimately, I wondered if the strength of character in these people, whose visible grit was recorded by the town photographer, had survived intact from that time to this. How much like them were their children and grandchildren—what continuity was there, and what were the changes almost fifty years later? If I met these people, what would I learn about them, and about myself? Whomever and wherever I photograph, it is not only a record for history and art, but also a learning process for me.

It would be ten years before my fascination with Disfarmer's portraits would begin to involve me personally. In the summer of 1987, after completing a series documenting the Shinnecock Indians of eastern Long Island, I purchased a 4 x 5 view camera and drove my van across country to Colorado to photograph the landscape I remembered from previous trips to the Navajo reservations. It was liberating to look out, far away, and focus on a vista instead of communicating with a portrait sitter, to learn the workings of a new instrument, and to look into the ground glass and see the rectangular format instead of the square of the Hasselblad, the camera I usually use.

On the return trip home, studying the worn Rand McNally Atlas, my eye dropped down from my planned Route I-70 East, to I-40 which runs through Arkansas. Where exactly is Arkansas located, I asked myself, and decided it was east of the west, and north of the south. Out of curiosity, I looked for Heber Springs but couldn't find it. I thought, perhaps the town no longer exists, or has been absorbed into a larger community over time, and continued my drive home. Later, when I learned that Heber Springs certainly did exist, I knew I would find a way to live in the town where Disfarmer had lived, and photograph the people he had photographed. And that happened two years later in 1989, after much planning and research.

In 1959, Mike Disfarmer's body was found on the floor of his studio by townspeople who became concerned when they realized they hadn't seen him lately. He had been dead for several days. After his death, Disfarmer's studio remained as he left it, with only time and an occasional intruder to add to its decline. Two years later, Joe Allbright, a newcomer to the town, heard that the old studio was going to be torn down. Joe came to the area as a major in the US Army Corps of Engineers, who were in Heber Springs building the Greers Ferry Dam across the Little Red River to help alleviate the flooding in the area. Among his other accomplishments, he later became

the town's mayor. Sensing the historical value of the glass-plate negatives he knew must still be inside, Joe decided to buy the contents of the interior from the bank that owned the property; they were sold to him for five dollars.

With his wife Ruby and his three sons, Joe went into the studio and removed as many crates of the old plates that they could store in their garage. In the process, they uncovered the bonds and cash, amounting to a sizable sum, that the eccentric Disfarmer had stashed away over the years in film boxes and tin cans. This money became the bulk of his estate and was divided among the remaining relatives from whom he disassociated himself and hadn't seen in many years. Shortly after, the bulldozers came and demolished the studio building; townspeople recall the sound of the large skylight and the remaining glass-plate negatives shattering as the place was flattened.

In 1973, Joe showed the glass plates to Peter Miller. Peter, formerly a photographer from New York, was the editor and a member of The Group, Inc., which published one of the local newspapers, *The Arkansas Sun;* he is now an attorney and lives in Little Rock. Peter was enthusiastic about what he saw, borrowed some of the plates, printed them, and published them in the newspaper as a promotion, offering an enlargement to anyone identifying the person shown. Realizing how unique and strong the images were, he offered to buy the dozen or so crates containing the remains of Disfarmer's life work. A deal was made for one dollar and a contract drawn up (Joe Allbright later mentioned that the money never changed hands). Joe turned over the negatives to Peter because he knew and approved of his plan to archivally preserve them.

Peter Miller took the old glass plates into his darkroom and after stabilizing and protecting them, printed the portraits. The resulting photographs confirmed his initial reaction to the plates. These were truly marvelous photographs, and there was something very special about them. He showed them to Julia Scully, editor of *Modern Photography* magazine in New York City, who shared his enthusiasm and suggested they collaborate on a publication of the Disfarmer photographs. They produced the book *Disfarmer: The Heber Springs Portraits 1939–1946,* with Julia Scully editing the portraits and writing the insightful and informative text. Subsequently, the prints were exhibited at the Arkansas Art Center in Little Rock, where the 3,000 contact prints Peter Miller made from the salvaged negatives reside. A traveling exhibition then toured the country and came to the International Center of Photography, where I was profoundly affected by the images. I saw them just after I made the commitment to become a full-time photographer and made

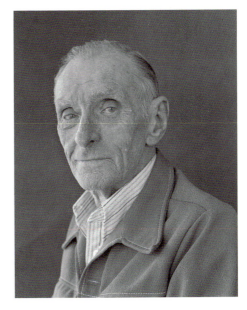

*Joe Allbright, 1989*

*Diane Bell Johnston, 1991*

my first portrait a few months later. In retrospect, my eventual decision to explore Disfarmer's territory was an acknowledgment of the impact his work had on me.

The only information I had about Heber Springs was in the book of Disfarmer's photographs. To begin working on the project, I contacted Peter Miller for further details about the town and the people. He was very cordial and offered to help me in any way he could. I learned that Heber Springs was the home of the Cleburne County Arts Council, whose president was Diane Johnston. It was my good fortune to meet Diane. Since the community takes great pride in the book, she was very enthusiastic about my proposal to live in Heber Springs, locate as many of the people appearing in the book of Disfarmer portraits as possible, photograph them and their families, or the descendants of the people portrayed, and tape oral history interviews with them. I also wanted to find out more about Mike Meyer, who became Mike Disfarmer.

Encouraged by my contact with funding agencies in Little Rock, I came to Arkansas to meet with them, and then drove the eighty miles or so north to Heber Springs on a road that was to become familiar to me—first the interstate and then a winding and twisting, two-lane hardtop with no shoulders, passing through countryside that Arkansas license plates aptly describe as "The Natural State." Coming from the lush and cultivated area of eastern Long Island, this landscape was austere to my eye. But in time I came to appreciate its clarity.

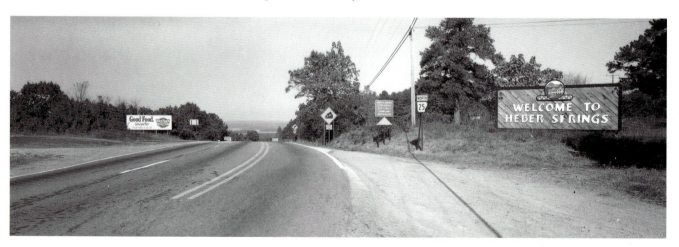

*Coming into Heber Springs, 1990*

Turning off Route 5 and onto Route 25 North, I approached the town and a billboard which read, "Welcome to Heber Springs." At that point the road seemed to fall off into a body of water. I was at the top of the dizzying

24

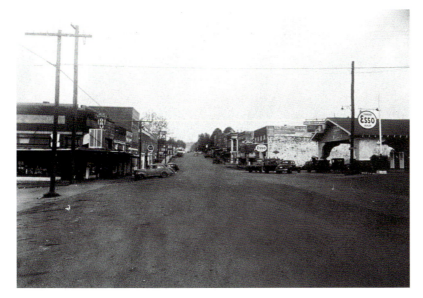

*Main Street, Heber Springs, 1940s*

*Main Street and Route 25N, Heber Springs, 1990*

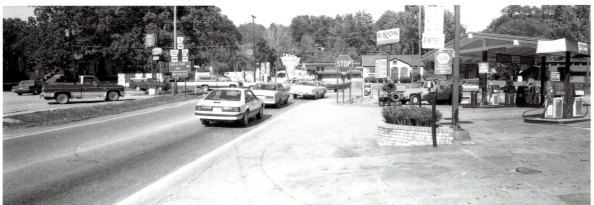

descent into town by way of a very steep, winding road which would test the driving skill of someone like myself, accustomed to the straight, flat, and fast Long Island Expressway and interstates that cross the country. The body of water in the distance was the beautiful lake created when the Greers Ferry Dam was completed in 1963.

At the bottom of the two-mile hill I passed a short commercial strip, similar to those in small towns throughout the country. At the stop sign of the busy three-way intersection was the Haile brothers' gas station, and on the opposite side of the road sat Lecil Bishop's Smokehouse Bar-B-Que restaurant. I would eventually meet these people and photograph them.

I made a right turn on Route 25, at this point also known as Main Street, and drove a few blocks to the "four-way stop," a well-known point of reference for directions. I passed stores located in two-story buildings of mixed architecture: the barbershop complete with striped pole, two drugstores

*Gem Theater, Main Street, Heber Springs, 1940s*

*(below) Sugarloaf Opry, formerly Gem Theater, Main Street, 1990*

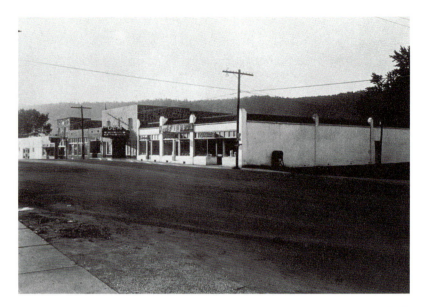

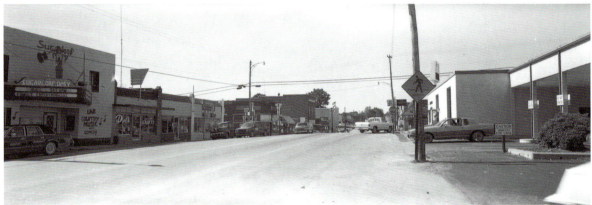

(one for the Methodists and one for the Baptists, I was told), furniture stores, clothing, automotive parts, appliances, two banks, an arcade with pinball machines and video games. Part of one side of the street had steps from the road leading to a raised sidewalk like the ones I've seen in western movies. There was the handsome and impressive court house, the Sugarloaf Opry (formerly the Gem Theater), the post office, and finally Spring Park, where the still-active mineral springs are located. Then I stopped the car. I found myself at the edge of town. These few short blocks were the Main Street of Heber Springs, Arkansas.

As prearranged, I called Diane Johnston, who had offered her gracious hospitality during my visit. I waited for her to arrive and lead me to her house. A handsome car drove up and out stepped a woman in a silk dress and high heels, with a very stylish haircut. Since my only frame of reference for the people of Heber Springs was the Disfarmer book, I was initially surprised.

26

Diane arranged for me to meet a group of Heber Springs residents who were very interested in having the community rephotographed by a photographer whose interests were documentary and related to history and art. The reception I received both in Little Rock and in Heber, as the townspeople call it, was very encouraging. I made the decision to return with the intention of living and working in the town for at least two years. Before I left, Diane took me to Spring Park so I could have a drink of the sulphurous spring water because, it is said, if you drink the waters you will return to Heber Springs.

Mike Disfarmer was a commercial photographer who built a proper professional studio, very sophisticated for the location, with living quarters in a single back room. And although I had a somewhat similar living and working situation, my goals were different: I am interested in creating a historical document, but also in expressing artistic intentions. I would not strive to emulate Disfarmer in this project, but instead would bring my own personal vision to bear on it. My photographs would be an extension of his portraits, not a re-creation.

To live in Heber Springs, to meet and photograph the people and make taped interviews with them, is a natural extension of my portrait-making and the documentation of continuity and change within the communities I observe. An update, or review, of Heber Springs would be consistent with past efforts to record cultural changes in America through the eyes of an artist with a camera. The work I have been creating for almost two decades is devoted to this idea.

For my previous projects, I would go to my subjects to photograph, setting up the portable poles and black background paper wherever there was acceptable light (I only use natural light for my portraits), and many times the light was not sufficient enough to satisfy my light meter. For this project, I wanted an informal studio that provided a predictable and reliable lighting situation, conveniently located and accessible to the people who were going to be photographed. I planned to tape interviews with the subjects of the portraits, and wanted to have the conversations in the person's home where it would be more intimate. It would also give me an opportunity to get out into the town and see the people in their own surroundings.

Moving to Heber Springs, I looked for an appropriate place to set up a studio, darkroom and living space. Diane and I chanced upon a large, A-framed house, the only one of its kind in the area. It was set on a point of land, high on a cliff over the shore of Greers Ferry Lake. And, with its high glass wall facing north, the first floor space would make a perfect studio. Although the

*Everett Henson, 1991*

house was located close to town, it was very isolated, with a long, bumpy road leading to it through the trees. Unused and neglected for years, it had an assortment of animals in residence. With planning, skilled workmanship, and patience, Everett Henson and his helper, Randy, made the house ready for me to begin work. Though informal and simple because it was temporary, Everett built me one of the best darkrooms I ever worked in and seemed to know what I needed before I asked.

After the studio, darkroom, and work area were set up, I turned my attention to meeting the people I wanted to photograph. First, I contacted the two local newspapers of the time, the *Cleburne County Times* and the *Arkansas Sun,* and told them about the project. Because this was a local issue, they promptly reported the story about "the New York photographer who has come to Heber Springs to photograph the people Disfarmer photographed." The article mentioned that I wanted to meet people who had their pictures made in the studio on Main Street, and would also like to meet their relatives and descendants. It was arranged for this information to be passed on to me, and several contacts were made. It was a good start.

I spoke to local organizations; mentioned the project in general wherever I went in the course of my day, in conversations at the bank, post office, supermarket, the auto repair shop; looked up names in the telephone book; and read the local newspapers, where familiar names from the Disfarmer book would occasionally appear. The people who contacted me, or whom I approached, were very willing to collaborate with me to create updated portraits of Heber Springs residents, and whose enthusiasm was inspiring.

Through my various methods of contacting people, I met and photographed many of those pictured in the Disfarmer book, or their relatives and descendants, to illustrate the continuity I believed or at least hoped was still there. I wanted to know if my portraits would reveal a visible change of character or if the inherent strength reflected in Disfarmer's photographs endured. And I also photographed those people who moved into the community since Disfarmer's time, and after Greers Ferry Dam was built, to perceive changes and growth in the town and to understand them.

In the courthouse I was able to locate documents regarding Mike Disfarmer's request to legally change his name; in the clerk's handwritten account are Mike Meyer's words, relating his strange, imaginative story. I also found the papers regarding his death and subsequent disbursement of his estate and the announcements of his name change and obituary in the newspapers' archives.

When I moved to Heber Springs and went to the post office every day to

get mail, I parked my van in the empty lot across the street, which was the site of the demolished Disfarmer studio. I was always extremely aware of this fact—and of where I was standing.

Photographing in Heber Springs, I had many memorable experiences. There was a mutual respect between the people I met and myself, and a spirit of working together to accomplish my goal. I was touched by the hospitality shown me and by the stories of their lives that I recorded on tape.

The first portrait I made was of Joe Allbright. I photographed Joe in his house because he was ill and unable to come to my studio. We had an interesting and informative conversation, which I recorded, about his salvaging Disfarmer's glass plates and turning them over to Peter Miller, and the old studio as he found it.

The second photograph was of Bessie Utley (Plate 3), Disfarmer's photography assistant in the early 1940s. Bessie, who is now in her eighties and a good storyteller, gave a lively account of working with Mike Disfarmer and some insight into how he lived. She told me how he taught her to develop the negatives from the Kodak processing part of his business—a necessary but distasteful chore for him, since he preferred to process and print only his own work. He made contact prints for his portrait customers—that is, he put the glass-plate negative, measuring either 5 x 7 or $3^1/_2$ x $5^1/_2$, directly on a light-sensitive paper or card of the same size, sometimes with a decorative border, and made the exposure.

His equipment was not modern, and he still used glass-plate negatives when celluloid film was readily available and used by his contemporaries. There is no evidence that he ever made enlargements of his work. A few larger prints were made for special occasions, but no doubt he sent the negatives to a studio outside Heber Springs for this procedure.

I am aware that real time does not stand still, and that faces reflect life's experiences. Yet, when I met someone whose face was familiar to me through the timelessness of a Disfarmer picture, and even though I knew better, I still expected to see the person look the same as he or she did in Disfarmer's portrait. After more than a decade of scrutinizing the unchanging images on paper, I was now confronted with real people who had gotten older, but whom I recognized. My amazement never diminished, and it was an extraordinary experience.

Disfarmer's reputation was that of a loner, and he was antisocial. His relatives, however, were warm hospitable people, who were very helpful and gracious to me.

Shortly after I arrived in Heber Springs, I received a phone call from Harry Neukam (Plate 1), the grandson of one of Disfarmer's sisters who lives in Little Rock. We met and spent some time talking about Harry's recollections of his great-uncle. Harry wanted to show me his collection of family memorabilia, which contained information about Disfarmer, and we arranged another meeting at his home.

It was a fascinating visit. There were countless, chronologically organized scrapbooks and albums filled with information Harry had scrupulously researched by combing church records, visiting cemeteries, and going through old letters and family documents. What interested me most, aside from the valuable family history, including dates of events, was an original letter written to Harry's father, Harry Neukam, Sr., by Disfarmer on January 20, 1936. He addressed him as "Dear Foster Nephew," and proceeded to tell the story

*Disfarmer's grave, Old Cemetery,*
*Heber Springs, 1990*

about why he is not "Mike Meyer," although paradoxically the letter is signed "Yours, Mike Meyer." (His legal name change took place three years later.)

I was shown photographs of Disfarmer through the years, and of the family, including his parents. There were also photographs of the house in Heber Springs, most likely taken by Disfarmer himself, both before and after the tornado that demolished it on Thanksgiving Day in 1926. Harry Neukam very generously allowed me to copy the material for inclusion in this book.

Some time later, Harry and his wife Norma came to Heber Springs to see the town once again and to be photographed in my studio. We also went to the old cemetery in town and visited Mike Disfarmer's grave.

Arkansas' Public Television Station, AETN, produced a popular weekly series, *The Arkansas Traveler.* Prior to my arrival in Heber Springs, there was a program about the book, *Disfarmer: The Heber Springs Portraits 1939–1946,* and the town itself. Its producer, Dale Carpenter, called me in Long Island

30

when he learned of my planned project, and we agreed to do a program about my work in Heber Springs. Dale came to Heber Springs several times to tape and interview for the show. One of the trips took us to Little Rock to interview Harry Neukam discussing his great-uncle and showing the family history books.

Louise Fricker, the wife of Roy Fricker (who is also a great-nephew of Mike Disfarmer, a grandson of another of Disfarmer's sisters), wrote to ask if I would be kind enough to point out in my book the positive aspects of Mike Disfarmer, his technical skill, and the genius of his accomplishments

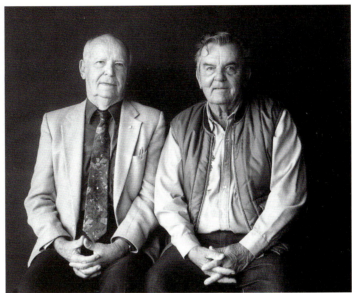

including his ability to build his own radio and cameras from kits. The Fricker family remembered the old photographer with affection and wanted to make sure his work was recognized as a legacy and document of the times. I eventually visited the Frickers on their farm in DeVall's Bluff, Arkansas, where I met the family: Roy and Louise, son David, daughter-in-law Verna, and Roy's brother and sister-in-law, Joe and Dorothy. The Frickers, like Harry Neukam, compiled family history books containing documents and family photographs which were invaluable sources of information about the mysterious photographer from Heber Springs.

While living in Heber Springs I participated in various events in order to meet the people, find potential portrait subjects, learn about the town, and in general, to take part in community life. I spent a large portion of my time in the darkroom developing negatives and printing, and it was pleasurable

*Louise Fricker, 1990*

*Joe and Roy Fricker, Mike Disfarmer's great-nephews, 1990*

31

to take a break from this routine to go out and mingle with the town's people. I found life in a small, rural town to be basic, friendly, and easy. It was quite different from the lifestyle I was accustomed to in New York City and eastern Long Island, where I moved after living in the city most of my life.

I attended many local events. At the high school I spoke about my work and showed photographs at High School Career Day and to the Gifted and Talented Class. On prom night, Diane Johnston and I prepared and served an elegant dinner at my house for her son, Benjamin and several of his friends, all of whom were dressed formally for the event. Although the light

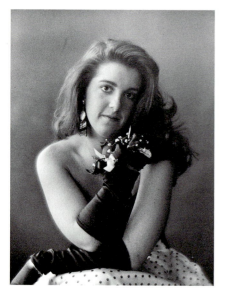 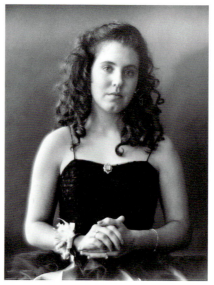 

*(left to right)*

*Donna Cooke, prom night, 1990*

*Summer Mozeko, prom night, 1990*

*Justin Deckard, prom night, 1990*

was low at that hour, I could not resist photographing some of my young guests. Afterwards, at 9:30 P.M., I joined the parents and other townspeople who were invited to the school gymnasium for a short time so they could see the decorations and watch the young people dancing. Since most of them attended their own proms at this same school, it was a nostalgic and happy event.

At the prom I noticed one of the students wearing an impressive black cowboy hat with his tuxedo. Wanting to photograph him in this outfit, I found out it was Todd Spinks (Plate 24) and contacted him the next day. Unfortunately, Todd had already returned the tuxedo to the rental store, and so we had to settle for a portrait of him in the black hat and everyday clothes. I later learned he was the grandson of Julia Chamness Carr, who was photographed by Disfarmer (Plate 21), and subsequently I photographed

his grandmother and his mother, Tricia Carr Spinks (Plates 22, 23). I was especially interested in these generational portraits. Todd was very enterprising and already had his own business, cutting and delivering firewood (he stacked mine perfectly), which paid for his impeccably maintained pickup truck. After high school graduation, he went off to college.

Meeting some of the older generation of townspeople allowed me not only to photograph them, but also to hear their recollections of life in Heber Springs and to learn more about Mike Disfarmer from those who had known him. A good place to start was the Senior Citizens' Nutrition Center. In Heber Springs the lunchtime meal is provided by the Cleburne County Aging Program and takes place at the Harmony Center. The people were very interested in my project. After explaining to everyone what I was doing, and getting formal permission from the director, I set up my camera and portable poles for the black seamless background paper near the large front window where the light was good, and began working. They enjoyed the session, giving each other good-natured advice over my shoulder about how to pose. The following week I brought them the promised prints of their portraits and found another group anticipating my arrival, wanting to be photographed.

I also visited the Lakeland Lodge Nursing Home where I met more of the older generation. But since I could not find sufficient light to work with, an outing was arranged for several of the residents to be brought to my studio by an attendant in one of their specially equipped vehicles. The following week about six of these old-timers arrived, several in wheelchairs. I had to work quickly because they could not stay away from their facility too long. This was difficult, however, because their curiosity about the new surroundings distracted them from paying attention to the camera. This session resulted in another memorable photographing experience.

Heber Springs has many churches, mostly Baptist and Methodist, but there are others, including Roman Catholic and Episcopal. Although I am Jewish, I went to many services at most of the denominations. At the invitation of Arbie and Homer Hayes, I attended one memorable service at the Hiram Union Church, located just outside of Heber Springs. There were eleven congregants on this particular sunny Sunday morning. Many churches in the rural areas have small congregations and cannot sustain a full-time preacher, so there are itinerants who go from one church to another to conduct the services. The serious, young man who preached this morning was particularly impassioned. After the sermon there were hymns, and, as a guest, I was invited to come up with several others to the area near the piano to sing. I

don't usually sing, but that morning I sang "The Battle Hymn of the Republic" with as much enthusiasm as the congregation.

Another unforgettable occasion was the services at the Lone Star Church in Greers Ferry, a town outside Heber Springs for which the Greers Ferry Dam and the lake it created are named. Guy Hazelwood and his daughter, Estelle (Sissy), invited me to services and a pancake breakfast, prepared by the men for the women and guests, to celebrate Mother's Day (see Plates 42, 43). Sissy, her hair brushed and shiny as usual, was wearing a pretty dress and a sweater with a corsage of white flowers. I asked her why she was wearing the corsage and she told me that on Mother's Day you wear red flowers if your mother is living, and white flowers if not. Sissy's mother, whom she missed very much, had died several months earlier. When I asked if I could photograph her she said yes, and asked if she could wear her corsage. I

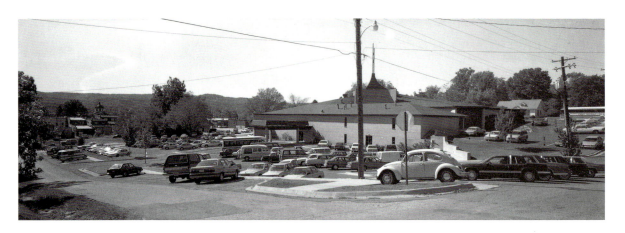

*Church on Sunday, Heber Springs, 1990*

pointed out that it might not be fresh by the time we do the portrait. She said that it would be okay because the flowers were made of plastic and chosen especially so they would last.

I gave lectures about my work and showed photographs at several of the Arkansas state universities and colleges, including the University of Arkansas at Little Rock and Fayetteville; and also, in Heber Springs, to the Cleburne County Arts Council and the Historical Society, local schools, photography club, and the Athena Club, a women's organization. I attended a Rotary Club luncheon and a Chamber of Commerce dinner for a state politician; visited Eustace Latch at his family-owned airport; had lunch at the top of Sugarloaf Mountain after climbing up with a forest ranger assigned by Carl Garner, chief engineer of the Greers Ferry Dam, to show me the view.

I photographed and interviewed Joel Irwin, the publisher of the *Cleburne County Times,* the day after he retired from the newspaper. Mr. Irwin's father

had been publisher before him. One of his sons, Matt, is a journalist for the paper, and the other, Jeff, is the pressman. The *Times,* together with the other paper in town, the *Arkansas Sun,* had just been bought by a large conglomerate and combined to form the *Sun-Times.*

Diane and Bill Johnston, and their sons, Benjamin and Matthew, acted as my family away from home. Diane, who is actively interested in her community and also an accomplished artist, used her imagination and creativity to help me accomplish my goals. She was an invaluable source of information about the town and surrounding area, and the customs and formalities of the people.

*(left to right)*

*Joel Irwin, publisher,* Cleburne County Times, *1990*

*Matt Irwin, journalist, 1990*

*Jeff Irwin, pressman, 1990*

  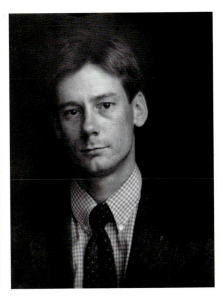

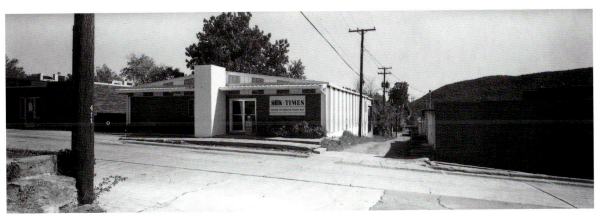

The Johnstons sustained me emotionally while I was living away from familiar surroundings for the two years I worked in Heber Springs. They made sure I was invited to family dinners and holiday events and included me in

*Office of the Heber Springs news-papers* (Sun-Times), *combined after purchase by a conglomerate, 1990*

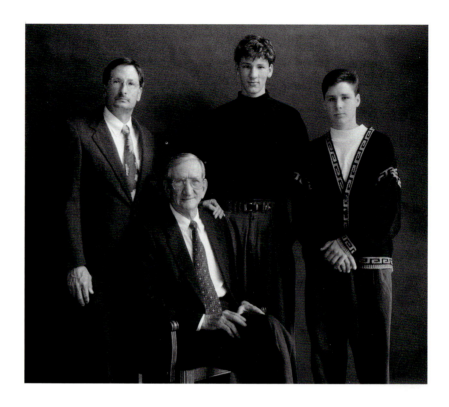

boating trips during the hot Arkansas summer, as well as local social events.
Bill taught me to build a good fire in my wood-burning stove and brought
me pine knots, the best wood for kindling, which he collected himself (I re-
ceived a bundle as a gift when I returned to Long Island). And I always ap-
preciated the astuteness of his observations and ironic sense of humor. Ben
and Matt, who were good friends as well as brothers, would show up unex-
pected and clear away brush or reload the porch with firewood.

Thurmon Bailey (Plates 15, 16), a man in his eighties, had endless inter-
esting stories (some of them spicy, which he obviously savored) to tell about
himself and life in Heber Springs in the old days, and since he considered
himself a friend of the eccentric Main Street photographer, stories about
Disfarmer as well. I enjoyed visiting with Thurmon in his house on First
Street, where he would be waiting for me at the appointed time, dressed im-
peccably in his white shirt and tie, and cowboy boots. He always had some-
thing ready to show me—scrapbooks with photographs and mementoes, old
newspaper articles to verify his stories—neatly arranged on a card table spe-
cially set up for us in the living room. His wife, Dorothy, always stayed in
the kitchen.

A few times we ventured out into the countryside in my van, Thurmon
sitting expectantly in the passenger seat next to me (I don't think he trusted

36

a woman driving a van), wearing his large, white cowboy hat. He pointed out various things to me as we drove on roads I would not have been able to find myself, pronouncing his words very precisely. Among other places, he showed me his old homestead, where his family lived for many years, and a "dog trot" house with its porch connecting two separate sections to allow for air circulation during the hot summers, a design common to the area in earlier times. One summer evening we walked to the rodeo at the county fairgrounds, just down the street from Thurmon's house. At the rodeo he pointed out the different kinds of horses and told me how to identify them, and explained the goings-on in general; after all, I was a "big city gal." About half way through the event it was time for the old gentleman to re-tire, and so I walked him home.

Louie Clark and his family (Plates 34, 35) impressed me with their sense of mutual devotion, which I observed in many of the families I met in Heber Springs. Louie is a man of many talents. Among his accomplishments, he col-lected information and old photographs for two books he wrote about the hamlet where he grew up, Wolf Bayou, located just outside Heber Springs, and had the hardbound books published himself. Louie is also a songwriter, making tapes while singing and accompanying himself on the guitar. He, his wife Ruby, and daughter, Jeannie McGary, generously helped me learn about

the community. While I was interviewing Louie, Ruby was in the kitchen with her granddaughter, Amanda Clark (Plate 36), canning peas. Jeannie McGary, who is married to an architect, took me to see their old family homestead, which she was planning to move to her property, intending to restore it.

Cloyce (Plate 30) and Dorothy Cannon own a poultry farm in Drasco not far from Cloyce's original homestead. After his family moved out, the place became a schoolhouse and later a gas station. The Cannons work hard to-gether, seven days a week, raising the chickens that they eventually sell to a large wholesaler. When I went to their place to deliver their portraits, Cloyce asked me if I liked turnips. He took me out to the garden, pulled the winter turnips right out of the ground and filled a carton for me in appreciation for the photographs.

I was invited to have meals with many of the people I photographed,

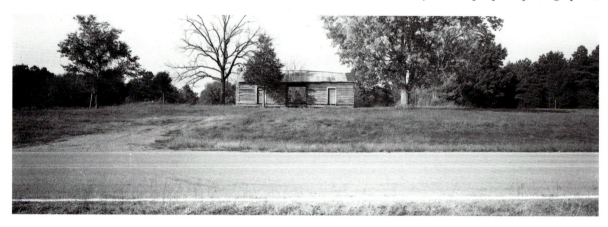

*"Dog Trot House," Heber Springs, 1990*

which I took as an acceptance of my efforts and presence in the commu-nity. One special memory is of lunch with Bynam Bullard (Plate 38) and his wife, Mabel, in the low-roofed, plain house they have lived in since they were married.

I picked up the Bullards one morning and brought them to the studio to be photographed, since Bynam no longer drives. When I took them back to the house, I was invited to stay for lunch. As the guest, I was asked to say grace before the meal, which I did. Bynam is a humble, dignified man, whose large hands reveal a life of hard work. He talked quietly about his family and their farm as we ate our lunch of boiled meat, potatoes, canned corn, greens, and bread at the kitchen table. Mabel and I talked about cooking and baking. She asked me questions to determine if I was as good a cook as I claimed to be, and seemed surprised when I gave the "right" answers. It was a heartwarming experience to share a meal with the Bullards.

*Clark Family homestead, 1990*

*(below) Cloyce Cannon's old homestead, 1990*

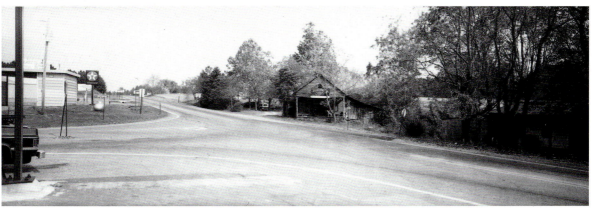

It took several trips and visits to their various homes before I was able to arrange to bring the three surviving Killion brothers (there were four), Andy, the eldest at ninety-three, Elmer, and Clifford to my studio for their portrait (Plate 33). Elmer was not included in the original Disfarmer portrait, taken on the day Clifford left for the army in the early 1940s (Plate 32), and John, who is in the old photograph, had recently died. The old gentlemen were amiable and it was evident they still enjoyed provoking each other good-naturedly.

Andy is a bachelor and lives alone in a small house on a nephew's farm. Since he does not have a telephone I could not let him know I was coming to see him and arrived unannounced. He was having a meal of warm milk and bread at a table placed near the end of an old sofa, sitting on the arm of the sofa as though it was a chair so he could look out the window. The house was very spare. I could see into the one bedroom and noticed that the

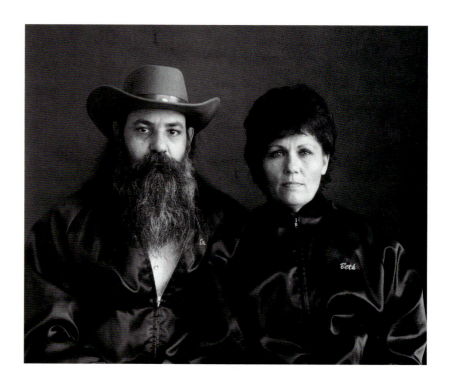

bed was neatly made. Though he didn't have much to say, he seemed glad to see me and smiled shyly during the visit.

Clifford Killion lives alone on his farm nearby and enjoyed talking about the old times. I visited him on several occasions and he took me with him to meet his relatives. At Christmas, Clifford made a gift for me—homemade peanut brittle.

I met David Dick outside Walmart's where he was selling raffle tickets for the local Vietnam Veterans Association, of which he is president. I photographed David and his wife, Beth, as part of the project to show the more recent residents who have made Heber Springs their home. In appreciation for the copies of their portraits, they invited me out for dinner. David had agreed to a taped interview and suggested I bring my recorder with me to the restaurant so we could talk during the meal.

As it happened, it was a day or two after the start of the Desert Storm invasion in Iraq. David spoke very eloquently for a long time about war—the one in Vietnam, and the war just beginning in the Middle East. I did not have to ask any questions. The live country and western music featured in the restaurant, heard clearly in the background on the tape, did not distract David from talking about a subject he knows well from experience.

Rex Harrel is an artisan and still works with an anvil. I visited him many

40

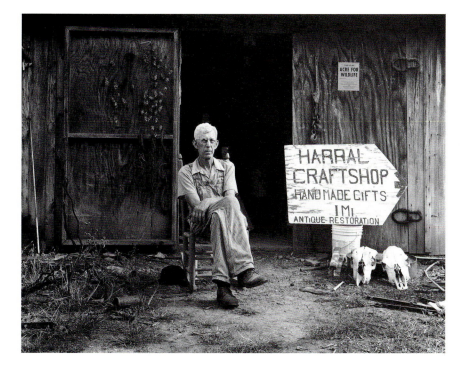

times on his farm and photographed him in the shed where he works making the objects he sells at local fairs. He also sells them out of his house, which is very hard to find in spite of the encouraging signs that appear intermittently on the long and winding dirt road leading to it. When I left, I would often find a bag of freshly picked vegetables from the garden waiting for me in my van.

I became aware that the Price Chopper Supermarket, one of the two places where I shopped for food, was more crowded on a Saturday because people came in from surrounding areas to do their weekly marketing. And these people interested me; I felt their faces showed strong character and I wanted to meet them and photograph them.

One Saturday morning, I arranged with the manager of the store to set up my camera and background paper in the glassed-in area at the entrance, where the food wagons are usually kept. Diane Johnston helped me with this arrangement. While I was busy working with someone who agreed to be photographed, she greeted people, showed the Disfarmer book to explain the project, and in her inimitable way convinced people to wait their turn for a portrait.

At one point, seeing a particular woman I wanted to photograph, I took the Disfarmer book, approached her and tried to persuade her to participate.

She shook her head no—she was not interested. But the page in the book I had randomly opened to caught her eye and she gasped. It was a picture of her parents and older sister (Plate 17) and she had never seen it before. Understandably, Lou Lawson (Plate 18) became very emotional and had to be seated. She then agreed with enthusiasm to be photographed, as did the daughter who was with her, Donna Warnick (Plate 19). Later in the day I made a portrait of a young man named Tyrone Phipps (Plate 20), and it wasn't until I was going to deliver the prints that I learned he was Lou Lawson's grandson, and Donna Warnick's son.

When the project was completed, just before I left Heber Springs, an exhibition of the photographs was held at the middle school for all the town to view the results of our mutual endeavor. Announcements were placed in the local newspapers and invitations sent out for a Sunday afternoon, timed for after church and the afternoon meal. The Arts Council women baked cake and cookies and set up a refreshment table. Diane Johnston and I spent the hours before the opening hanging the approximately two hundred portraits in the long, well-lighted entrance hallway. There were not only my recent portraits, but hanging next to them were the portraits of the same people made by Mike Disfarmer from the 1940s.

A pleasurable and satisfying aspect of my work is to exhibit newly completed work in a location where the people in the photographs can come to view their own portraits. Many people showed up even before the announced time, bringing family and friends. They compared the photographs with amazement and some, provoked by the Disfarmer images, recalled the past with nostalgia.

It was wonderful for me to see these now familiar faces all in one room— and in a form other than an image caught by the split-second snap of the shutter and affixed to paper. They were expressive and vocal and enjoying themselves.

Some chairs were thoughtfully provided for those who needed to sit, and Percy Clapp placed a chair beneath the portrait of his recently deceased wife Mary (Plate 45), who was Joe Allbright's sister, and sat there in his quiet and dignified way, his hands resting on his cane, for the duration of the event (Plate 44).

When the exhibition was over, I presented a complete set of the portraits to the Cleburne Country Arts Council to preserve for the town. The Arts Council is now located in their new building where the portraits are occasionally displayed.

Recalling these events and assembling images for a book that represents two years of working and living in an unfamiliar community has compelled me to focus on the unforgettable impressions of the experience.

Having lived in Heber Springs, I am forever enriched. Invited to take part in the lives of those I photographed has enabled me to meet and know extraordinary people who I will always remember. I am impressed with them for the same reasons the original Disfarmer portraits moved me—their honesty, integrity, and humanity.

Heber Springs has changed over the years, but what I saw in the faces of those impressionable images years ago, is intact.

# THE TOWN OF HEBER SPRINGS

TOBA PATO TUCKER

The town of Heber Springs is very quiet, and it's easy to go about the business of everyday living. The people are friendly and there's a howdy and a smile even for a stranger. On the local roads you always get an "Arkansas hello" from passing drivers who have both hands on the wheel and raise their forefinger to you in greeting (it took me a while to catch on to this).

Beyond the commerce on Main Street, up the steep hill of Route 25 from the four-way stop, there is a strip mall with the popular and ever-present fast-food restaurants and other businesses that serve the needs of Heber Springs, which is like the hub of a wheel to the surrounding towns and hamlets. On that one strip of about a mile I could pay my rent and water bill, stock up on groceries, buy anything I needed for repairs, replace tires, do my laundry, and wash my van. At the end of the strip and around the sharp curve was the road to my house and studio.

Accustomed to living close to the ocean on Long Island, I was fortunate to be in a house near a body of water, situated on a cliff above Greers Ferry Lake. The enormous and impressive Greers Ferry Dam was located out of sight just around the bend. The lake was very active during the spring, summer, and fall, with sleek, noisy speed boats that looked capable of soaring to Mars, and "party barges"—open flatboats on pontoons protected from the hot Arkansas sun by colorful canvas roofs and populated by families, some with teenagers blaring their boom boxes. Very early in the morning, when it was quiet and the light was soft, the fishermen would be out to catch the bass and trout that thrived in the lake. Or they would be fly fishing from rowboats, or in wading boots, just downstream from the dam on the Little Red River.

The Greers Ferry Damsite Park, with its campsites and trails, is managed and meticulously maintained by U.S. park rangers. It is a great attraction for visitors and family vacationers in season. The town of Heber Springs has prospered and grown as a direct result of building the Greers Ferry Dam and the Damsite Park. It has become a popular recreation and resort area for boating, fishing, and vacationing and has a notable community of retirees originally from other parts of the country. The economy today is very different from

what it was when Mike Disfarmer photographed the community of Heber Springs in the thirties and forties.

The residential areas downtown near Main Street are mostly older and have interesting architecture reminiscent of earlier times; newer, more affluent-looking houses surround the town. Most of the older houses have "potato cellars," or storm shelters, for protection from the ever-present threat of tornados. And interspersed among the houses and businesses are the churches, mostly Baptist, Methodist, and Pentecostal.

Heber Springs is fairly self-sustaining, with local shops and stores supplying basic needs. Recently, a couple of large national chain stores have appeared pushing some of the small, family-owned shops out of business. I drove the eighty miles or so to Little Rock every few weeks to buy photo supplies, attend to business regarding grants, give lectures at local and state universities,

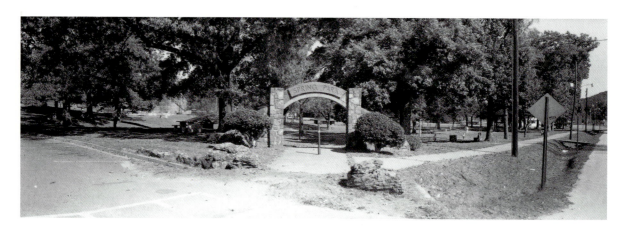

*Spring Park, where the springs are still active, 1990*

and catch up on current films, since the small Heber Springs movie house tended to cater to the young people in town.

"Spring Park," the reason for the popularity of Heber Springs as a resort earlier in the century, still has active springs—people bring their plastic jugs to fill up with the waters and carry them home. And it is still the place where the "Old Soldiers Reunion" celebration takes place. A small amphitheater in the park provides a venue for summertime concerts, as well as the "Miss Cleburne County" contest.

The town is like most small towns. It has an elementary, middle, and high school, police department, town hall, courthouse, hospital, post office, chamber of commerce, library, newspapers, an airport for single-engine planes, historical society, senior citizens center, shelter for women and children in need, an industrial park with light industry, and a local arts council. It also has an active county fairgrounds where cattle are judged, and a rodeo. The grounds

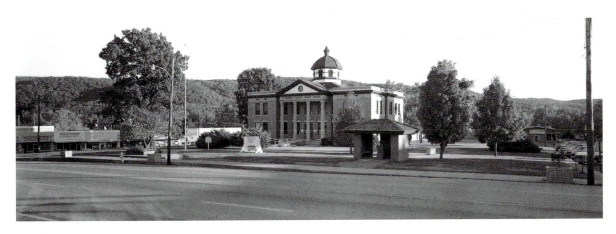

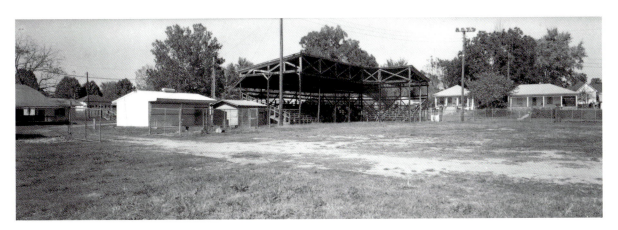

*(top to bottom) Cleburne County Courthouse, Main Street, Heber Springs, 1990; "Potato cellers" or storm shelters, Heber Springs, 1990s; County Fairgrounds, Heber Springs, 1990*

of the courthouse are used for arts and crafts fairs organized by various organizations for their benefit; and there are parades with different themes. I was honored to be selected as a judge for the "Ozark Frontier Trail Festival," and also sold ice cream at a booth. Fireworks on July Fourth are sponsored by a local manufacturing firm, and music recitals and art auctions at the Red Apple Inn are presented by the Cleburne County Arts Council.

Everyone is interested in local politics since those elected and in office are generally known to their constituents throughout their lives. However, occasionally a "newcomer" like Joe Allbright will be elected. While I was living in Heber Springs, Alice Mae "Jo" Hunt was mayor.

PLATES

1   *Harry Neukam, Mike Disfarmer's great-nephew, 1990*

*2   Bessie Utley with daughter Hazel*
*by Mike Disfarmer*

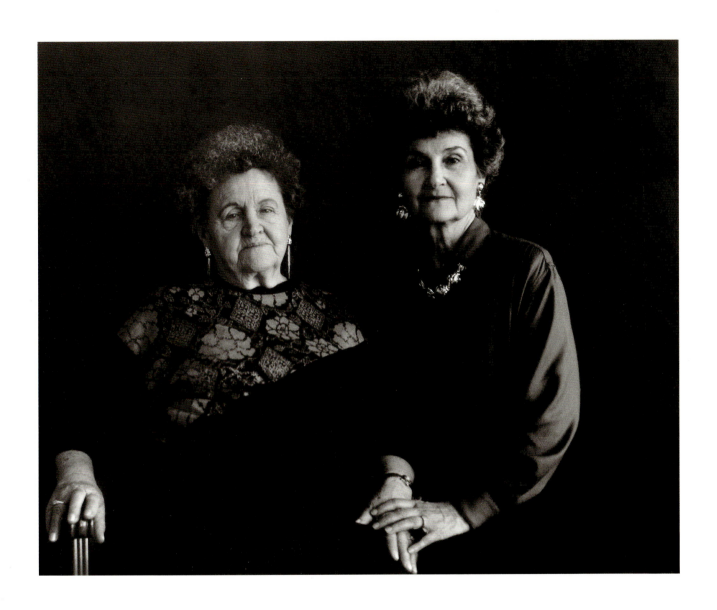

3    *Bessie Utley with daughter Hazel Cain Tate, 1991*

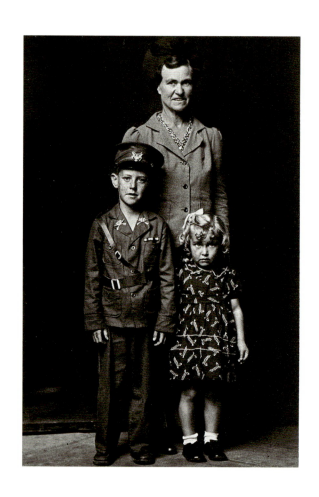

4    *Mattie Bishop with Lecil and Nina*
*by Mike Disfarmer*

*In an interview, Lecil Bishop said that his mother*
*bought his uniform through the Sears-Roebuck catalogue.*

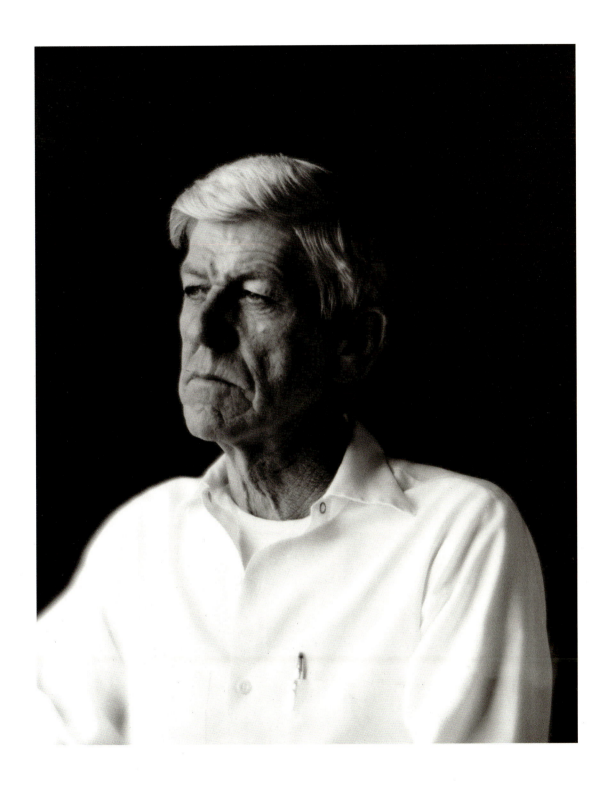

5    *Lecil Bishop, 1990*

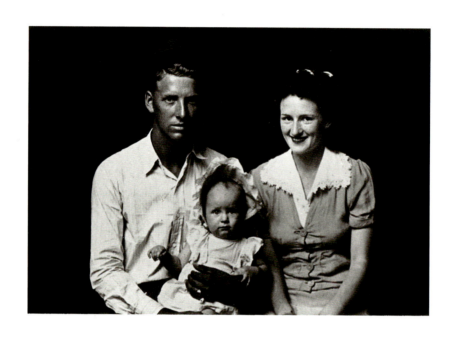

6   *Juel and Audra Hipp with daughter Janice*
*by Mike Disfarmer*

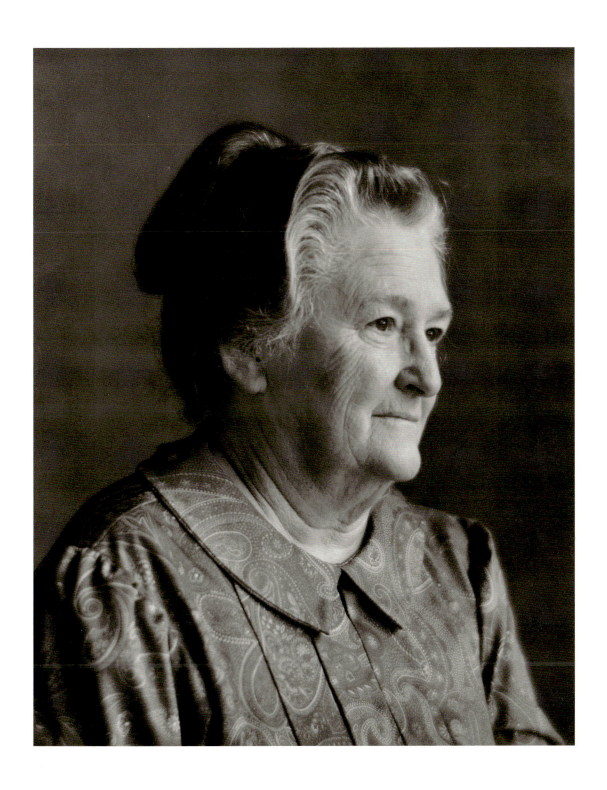

*7   Audra Hines Hipp, 1990*

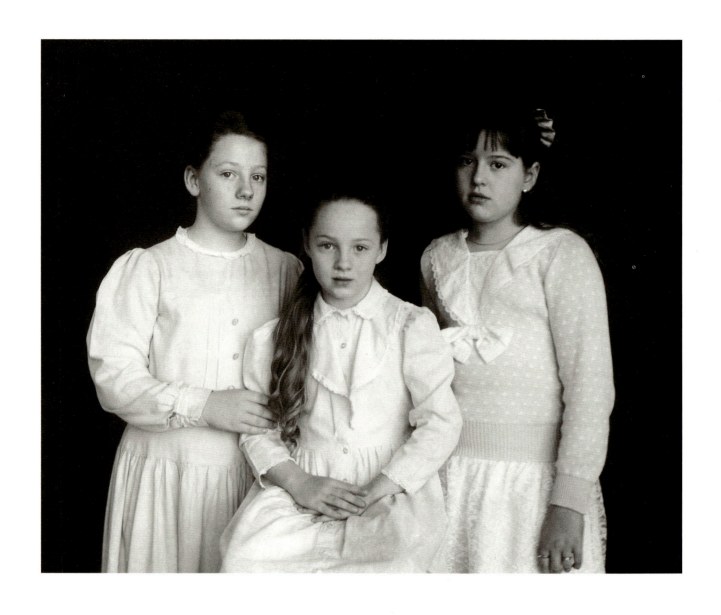

8 *Tammara and Elizabeth Cooper and Tiffany Cooper, granddaughters and*
*great-granddaughter of Juel and Audra Hipp, 1990*

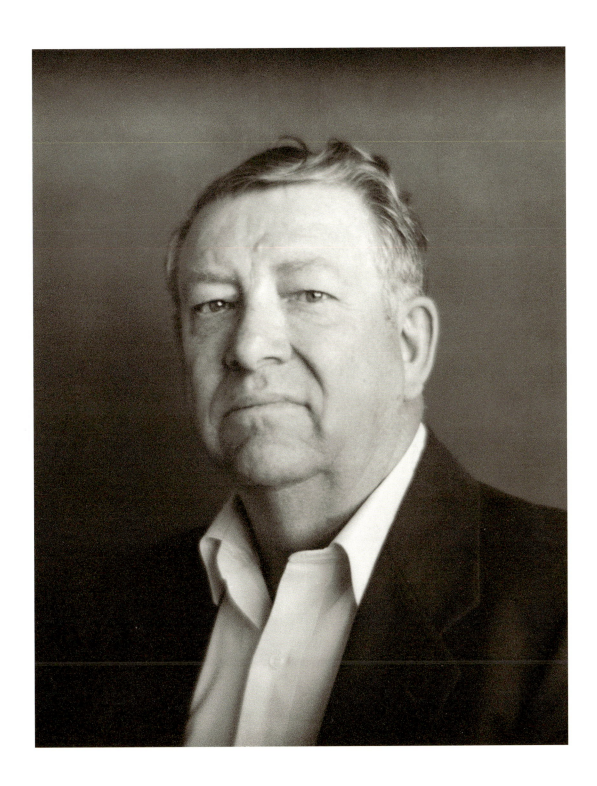

9    *Juel Hipp, 1990*

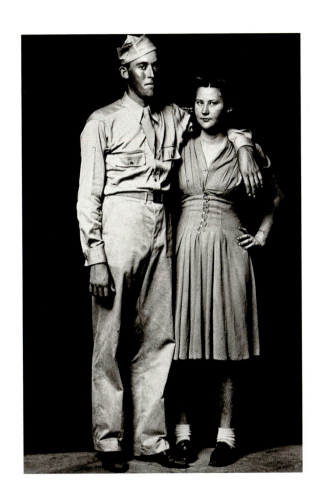

10   *J. C. and Irma Dean Verser by Mike Disfarmer*

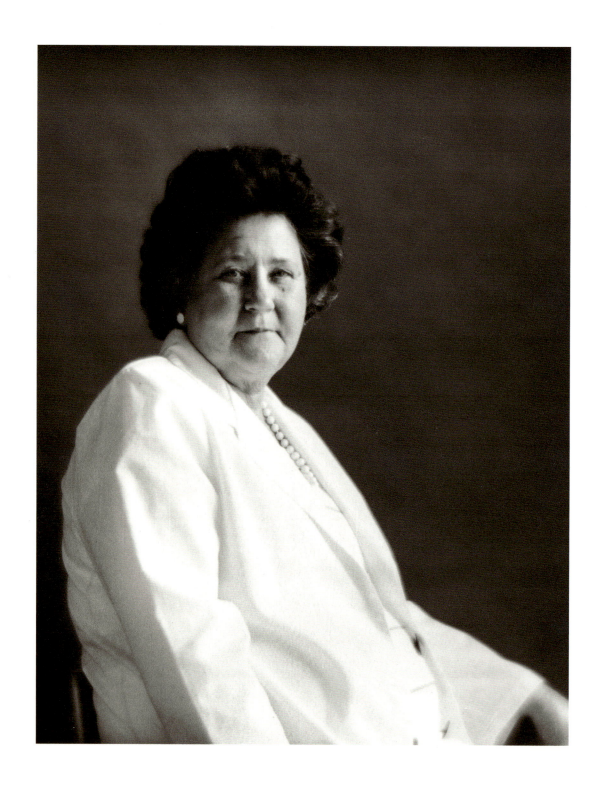

11   *Irma Dean Verser, 1990*

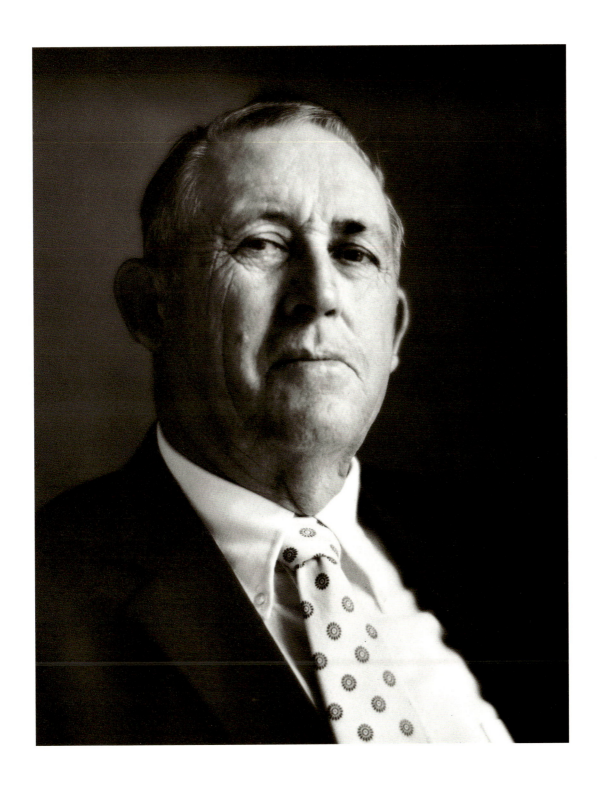

12    *J. C. Verser, 1990*

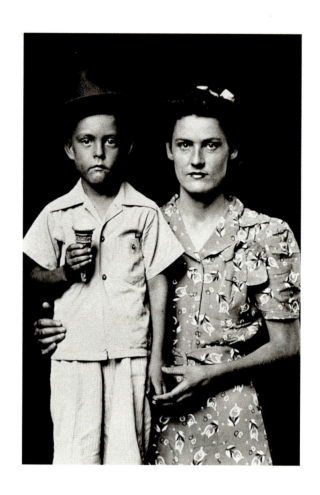

13　*Hulon and Lois Rice*
*by Mike Disfarmer*

*Mrs. Rice said she was just walking by*
*Disfarmer's studio with her son and had*
*no intention of being photographed, but*
*Disfarmer asked her to come in for a picture.*

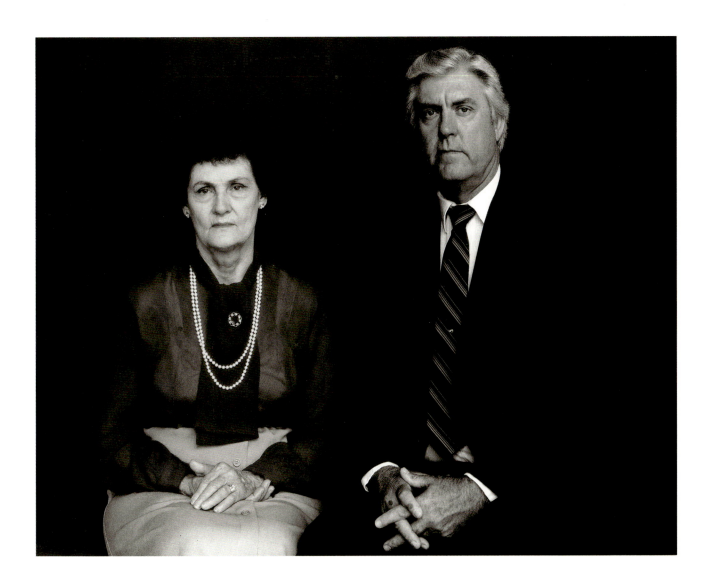

14   *Lois Rice and son Hulon Rice, 1989*

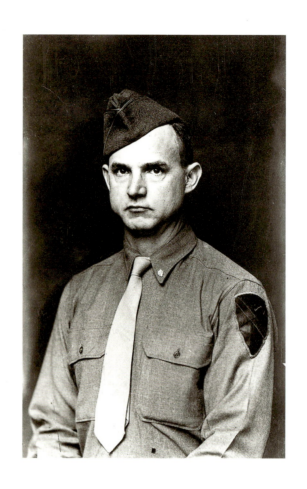

15    *Thurmon Bailey by Mike Disfarmer*

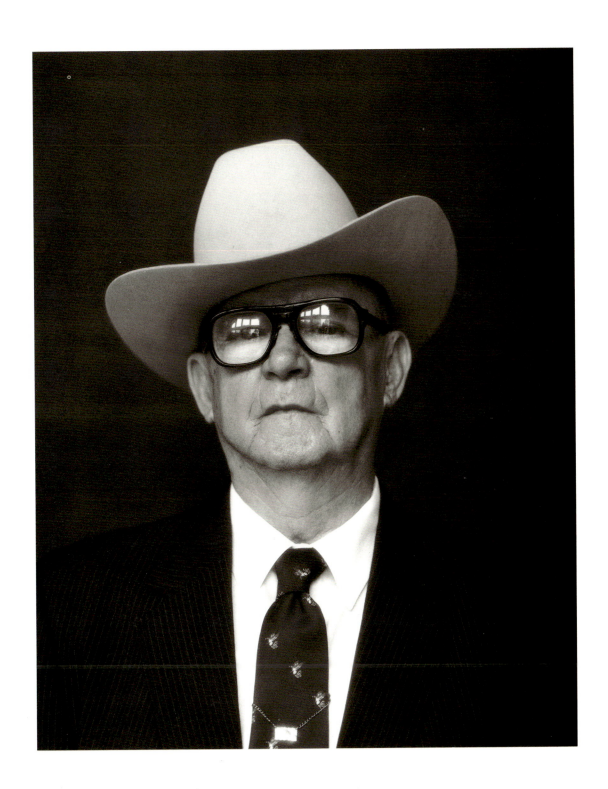

16    *Thurmon Bailey, 1989*

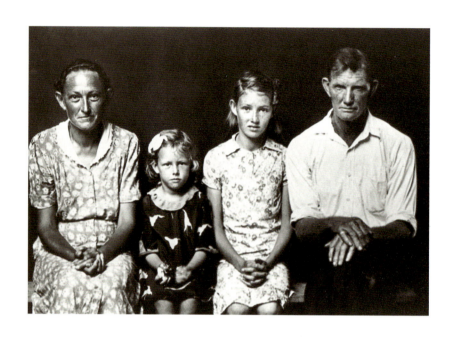

17    *"Red" Morton and family*
      *by Mike Disfarmer*

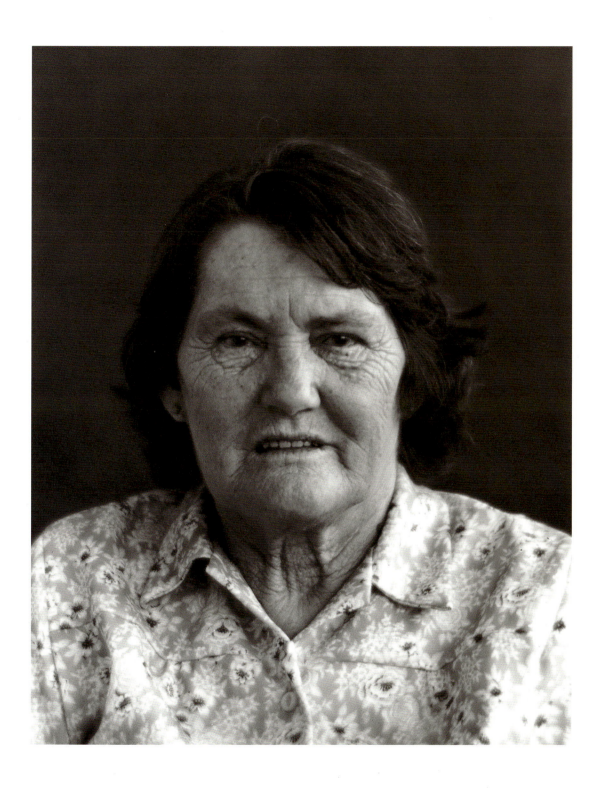

18    *Lauraine Morton Lawson, "Red" Morton's daughter, 1990*

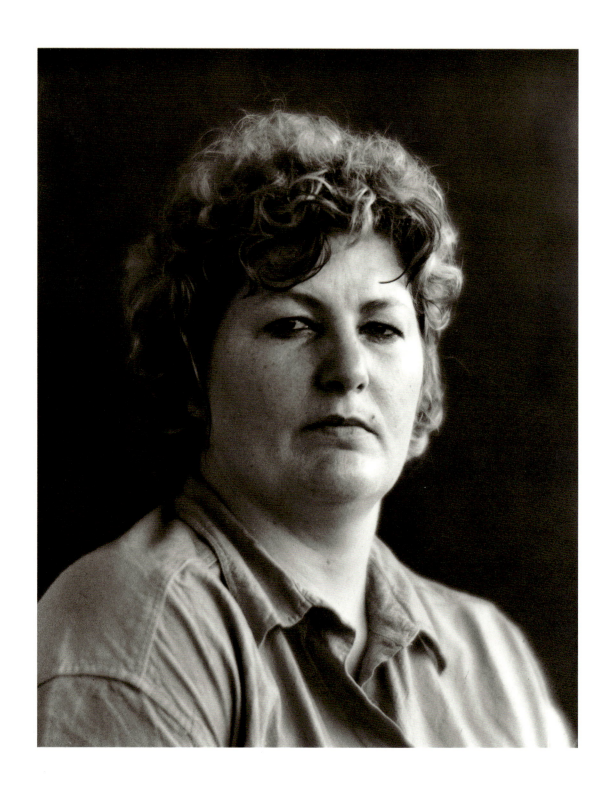

*19   Donna Lawson Warnick, "Red" Morton's granddaughter, 1990*

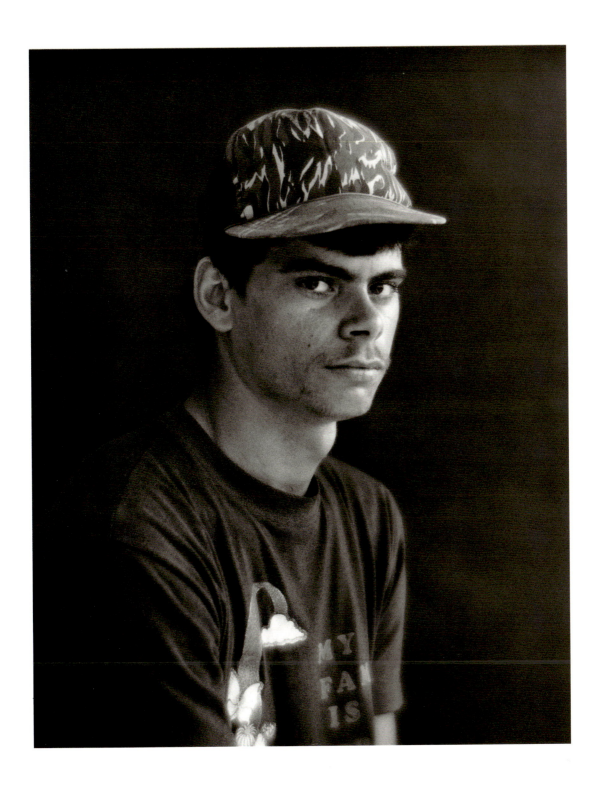

20    *Tyrone Phipps, "Red" Morton's great-grandson, 1990*

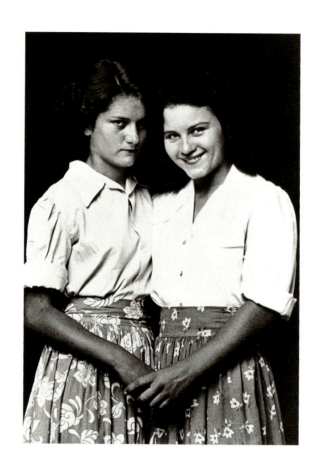

*21   Julia Chamness and Nellie Newman*
*by Mike Disfarmer*

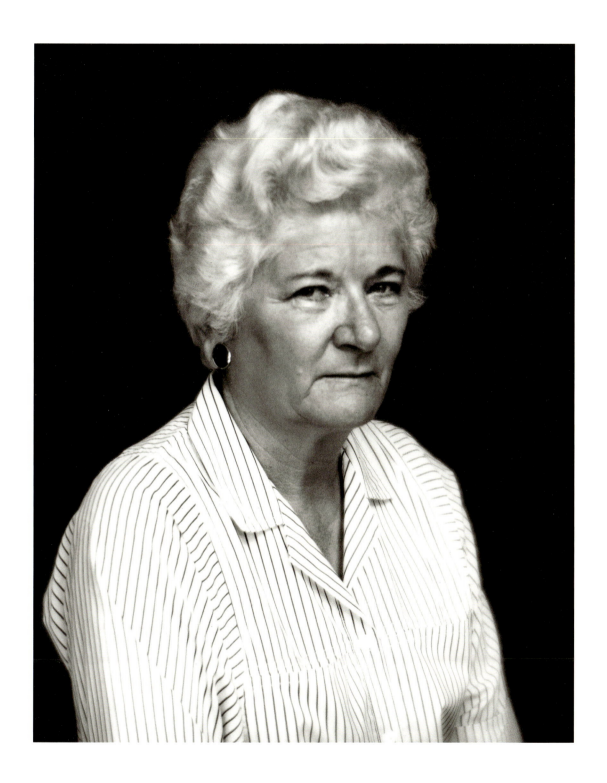

22   *Julia Chamness Carr, 1990*

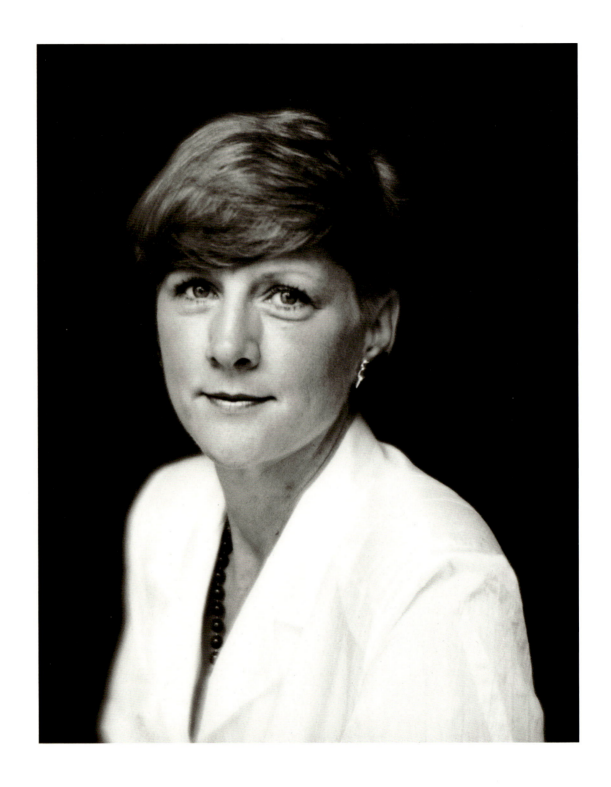

23   *Tricia Carr Spinks, Julia Chamness Carr's daughter, 1990*

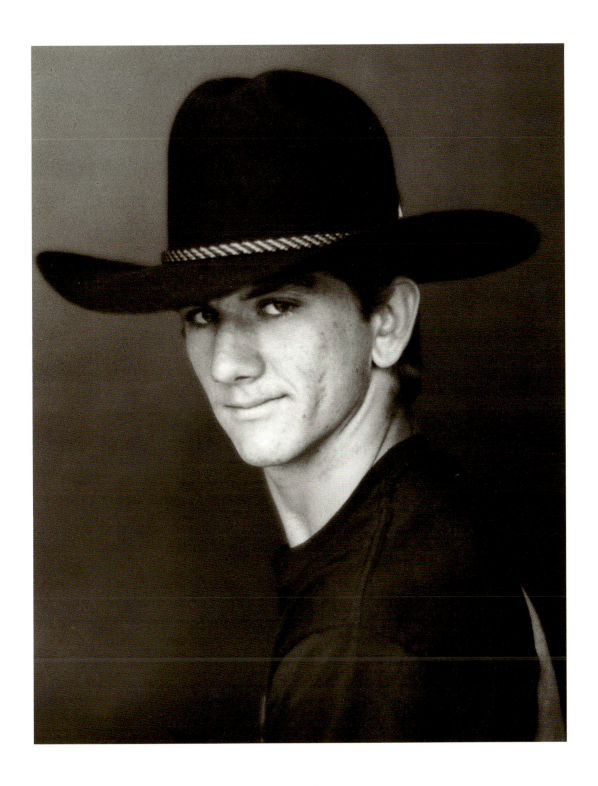

24    *Todd Spinks, Julia Chamness Carr's grandson, 1990*

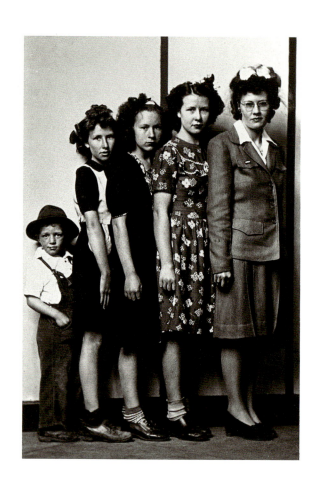

25　*Merlon Noah, Emmagean Faust, Ruth Faust,*
*Abagail Faust, and Eula Faust Mannon*
*by Mike Disfarmer*

*Merlon Noah got into the photo at the*
*last moment—he wasn't supposed to be there.*

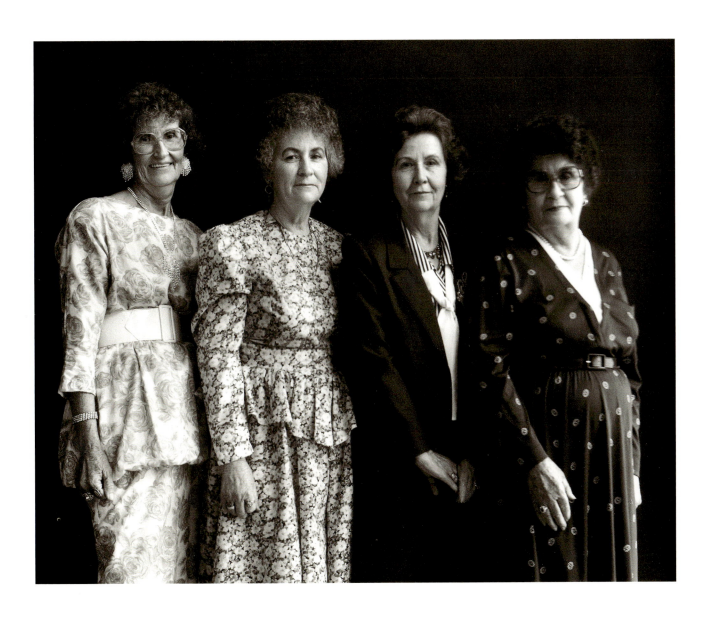

26    *The Faust sisters, Emmagean Burleson, Ruth Hartwick, Abagail Galloway, and Eula Mannon, 1991*

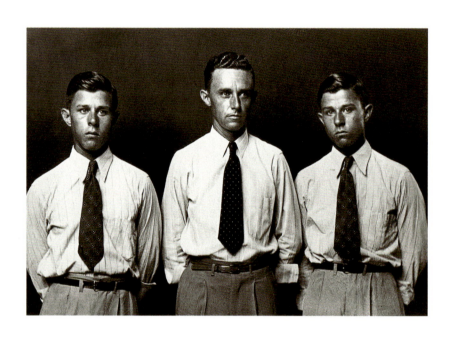

*27    Buel, Elbert, and Jewell Haile*
*by Mike Disfarmer*

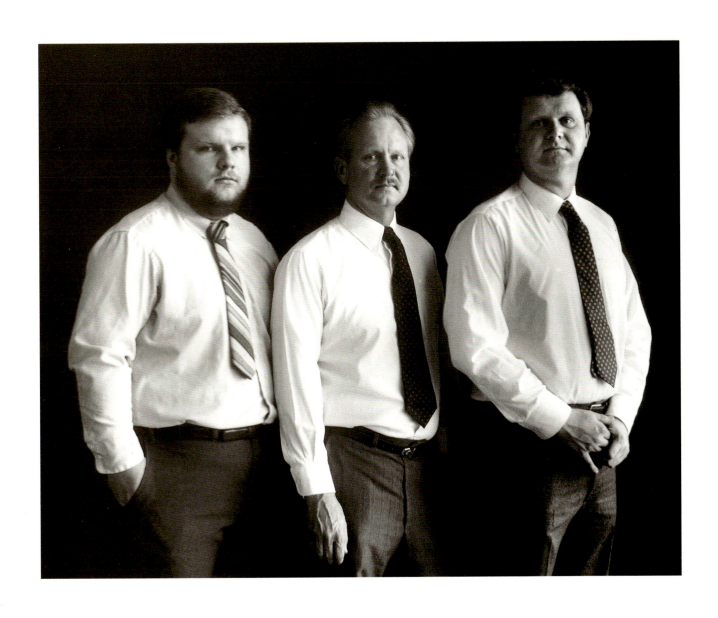

28    *Mike, Samuel, Jr., and Steve Haile, brothers, cousins of Buel, Elbert, and Jewell Haile, 1991*
*They came dressed this way with no prompting.*

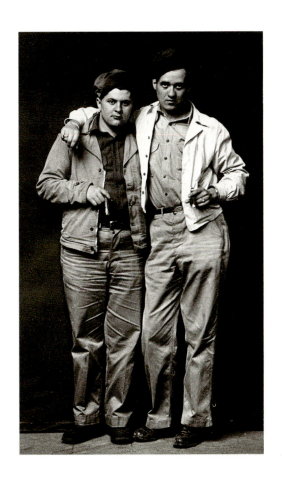

29    *Cloyce Cannon and Loy Cannon,*
      *cousins, by Mike Disfarmer*

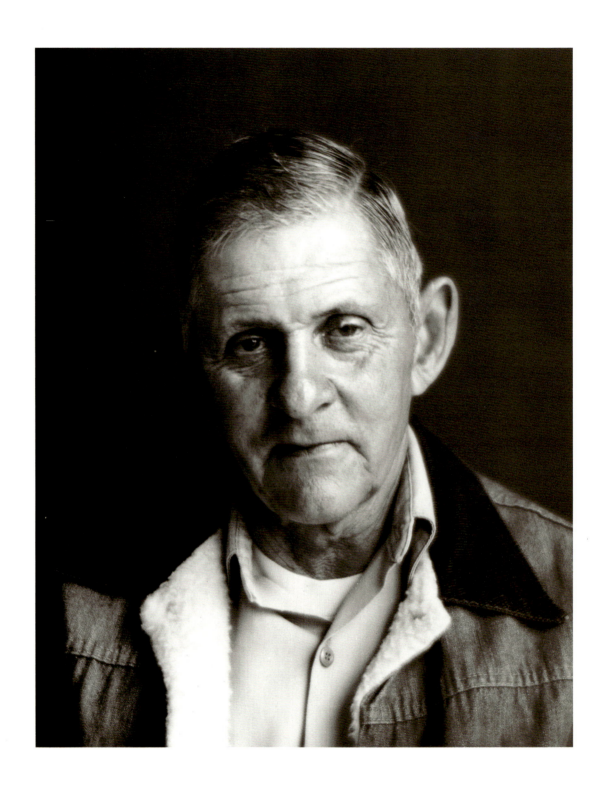

*30   Cloyce Cannon, 1990*

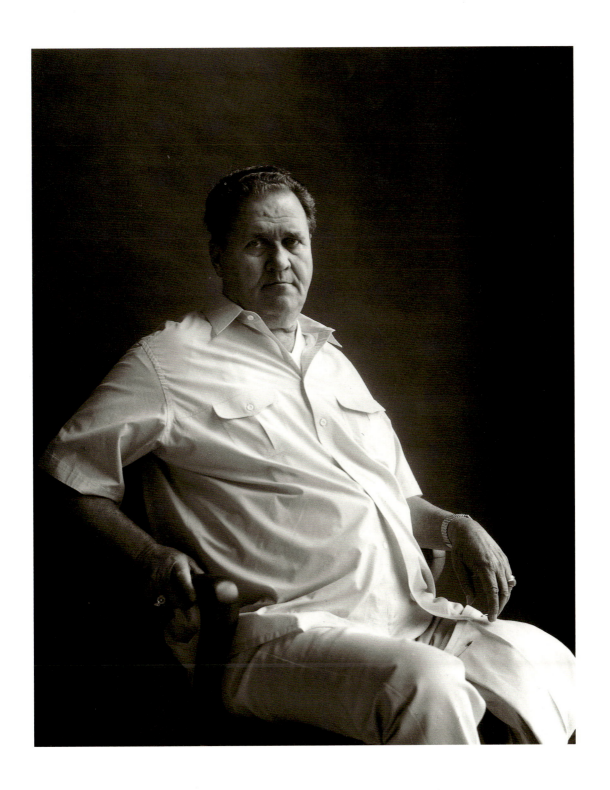

31　*Loy Cannon, 1991*

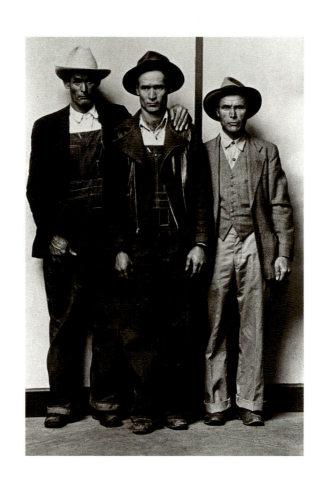

*32   John, Clifford, and Andy Killion, brothers,*
*by Mike Disfarmer*

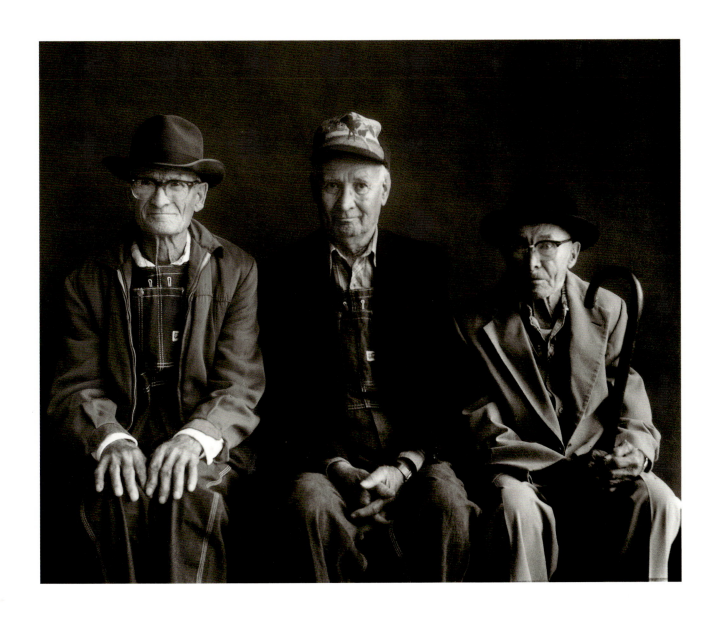

33   E. W. "Elmer" Killion, C. M. "Clifford" Killion, and A. M. "Andy" Killion, brothers, 1991

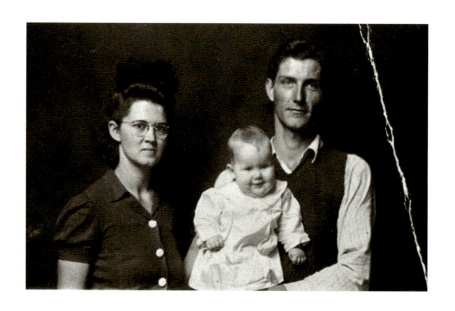

*34    Ruby and Louie Clark with Jeannie*

*by Mike Disfarmer*

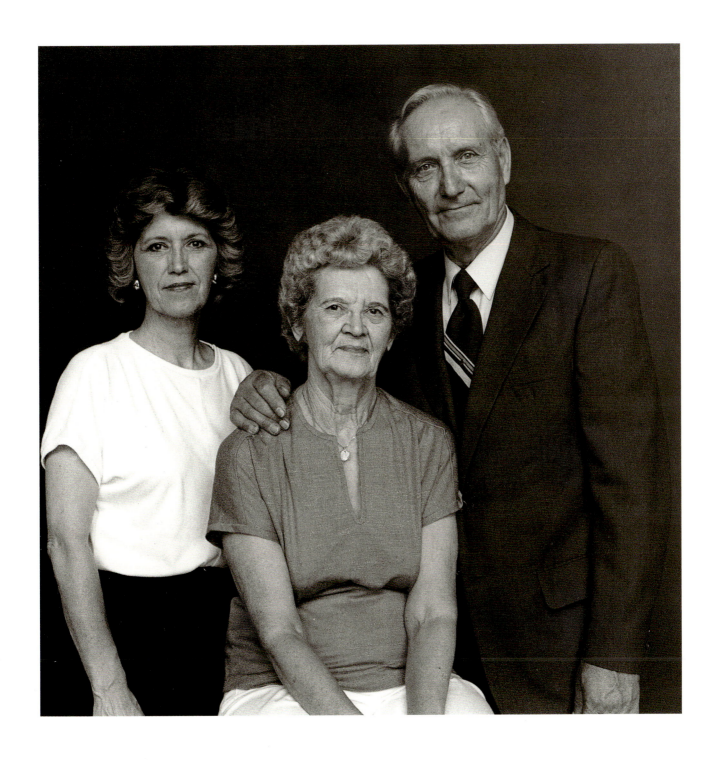

35    *Jeannie Clark McGary with her parents, Ruby and Louie Clark, 1991*

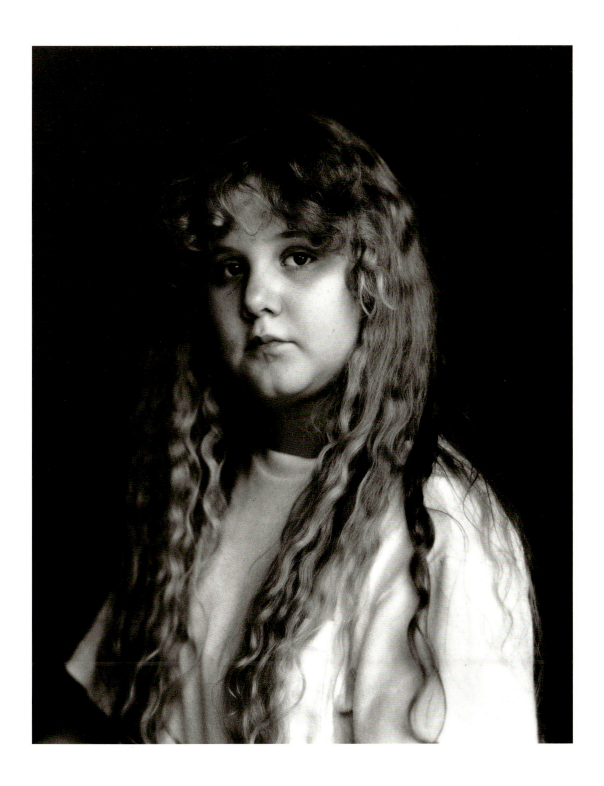

36   *Amanda Clark, Ruby and Louie Clark's granddaughter, 1989*

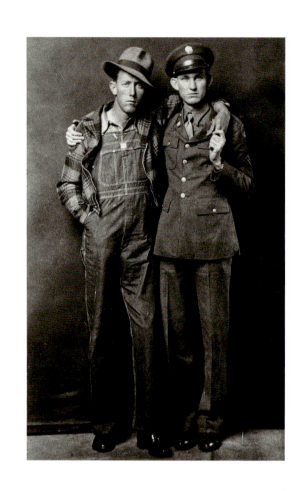

37 *Floyd Bittle and Bynum Bullard*
*by Mike Disfarmer*

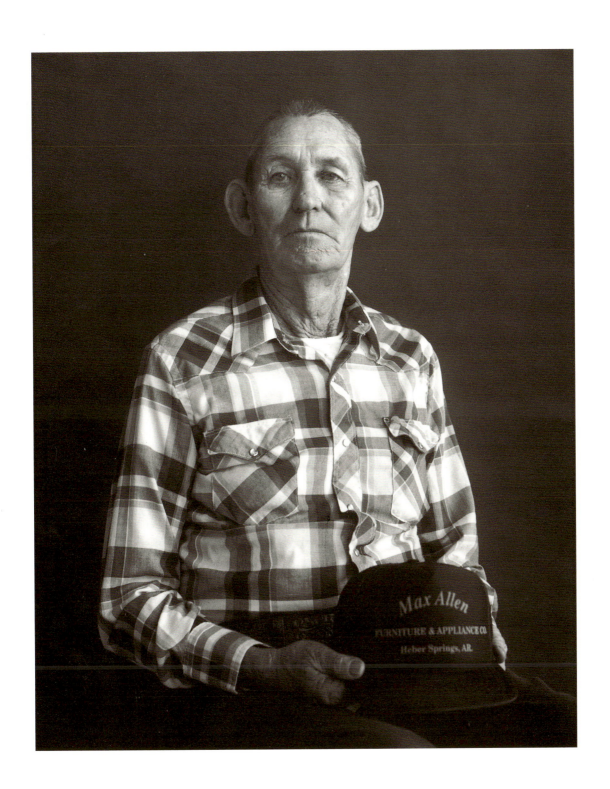

38    *Bynum Bullard, 1990*

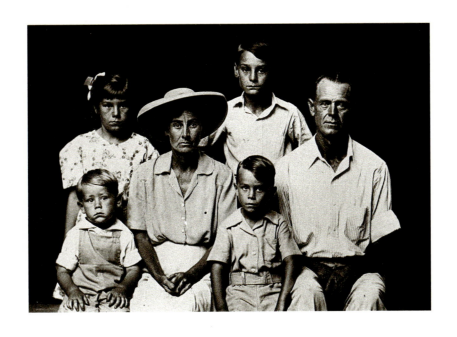

39    *Edith and Joe Bittle with Ken and Tatum (front row),*
      *Ada Mae and Clyde (back row) by Mike Disfarmer*

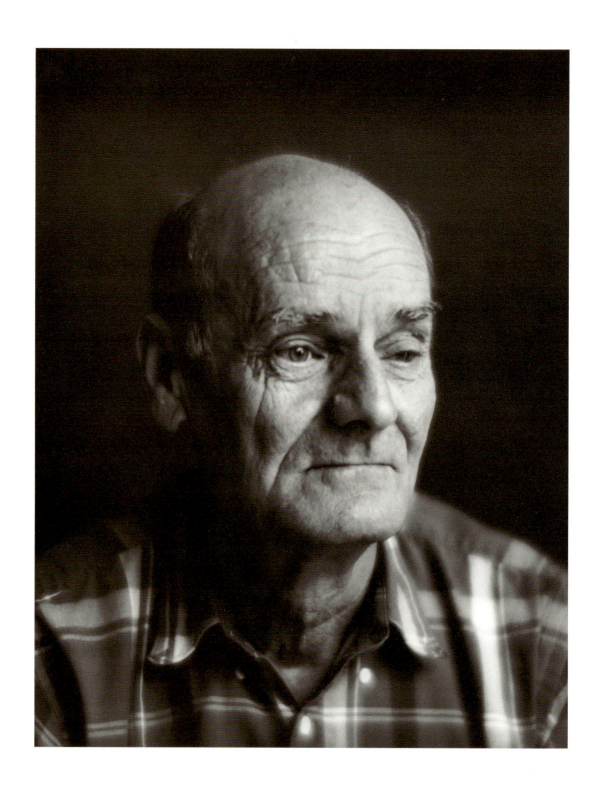

40    *Clyde Bittle, 1990*

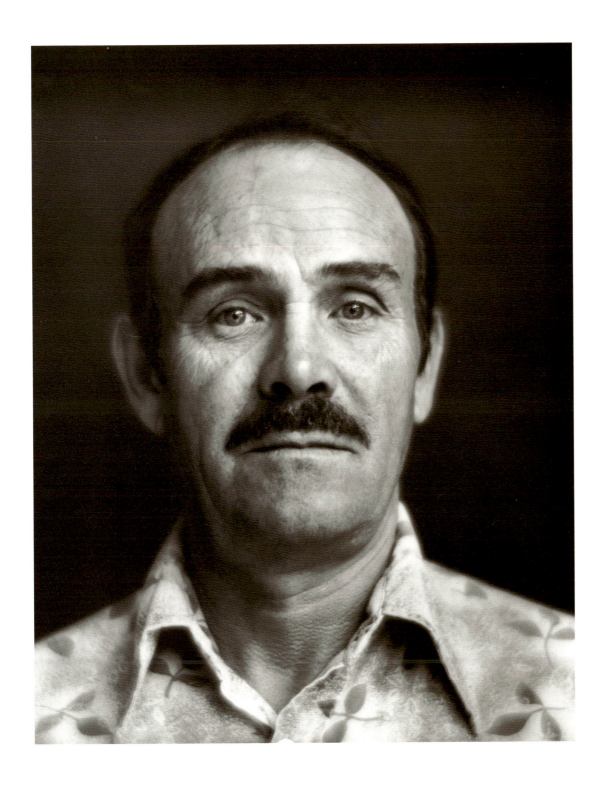

41    *Tatum Bittle, 1990*

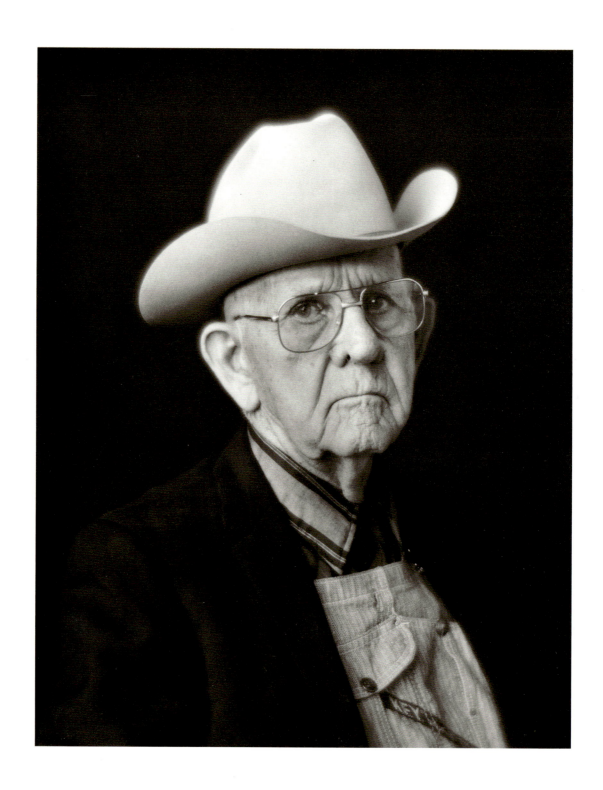

*42   Guy Hazelwood, 1990*

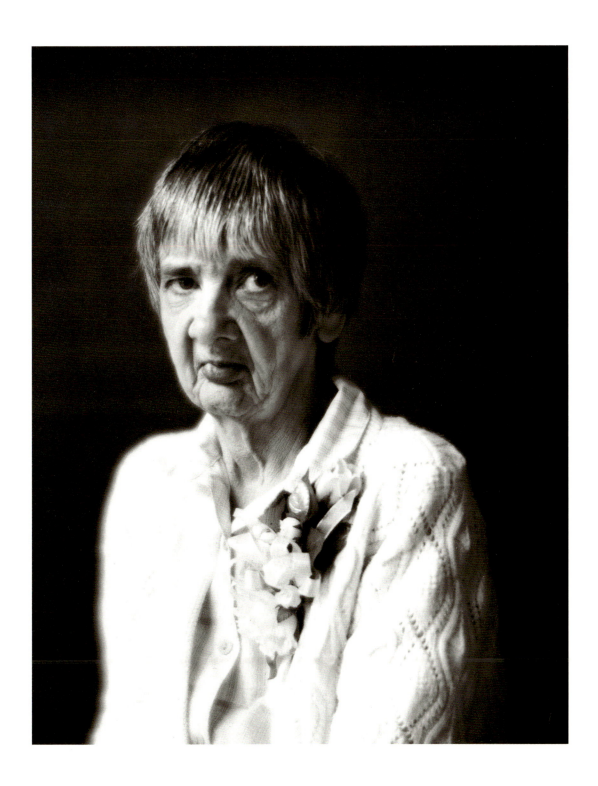

43    *Estelle "Sissy" Hazelwood, Guy Hazelwood's daughter, 1990*

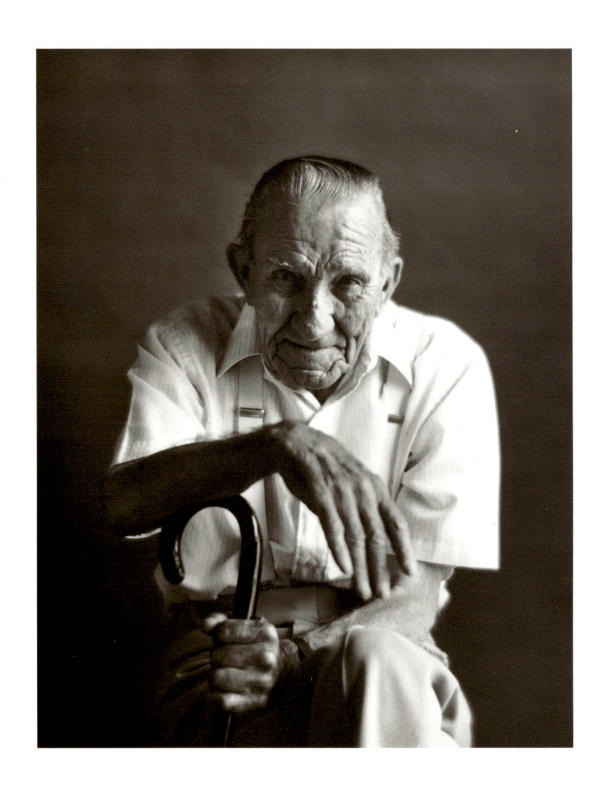

44    *William Percy Clapp, 1990*

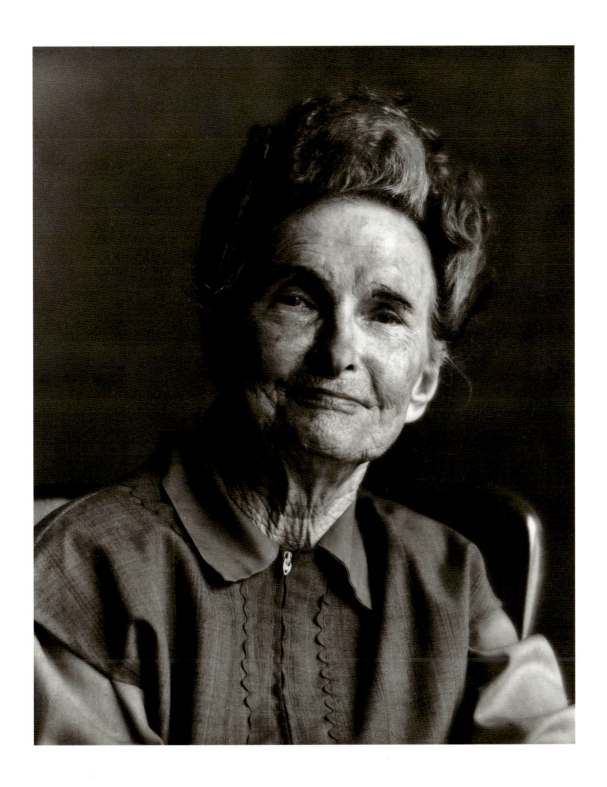

45    *Mary Elizabeth Clapp, Joe Allbright's sister, 1990*

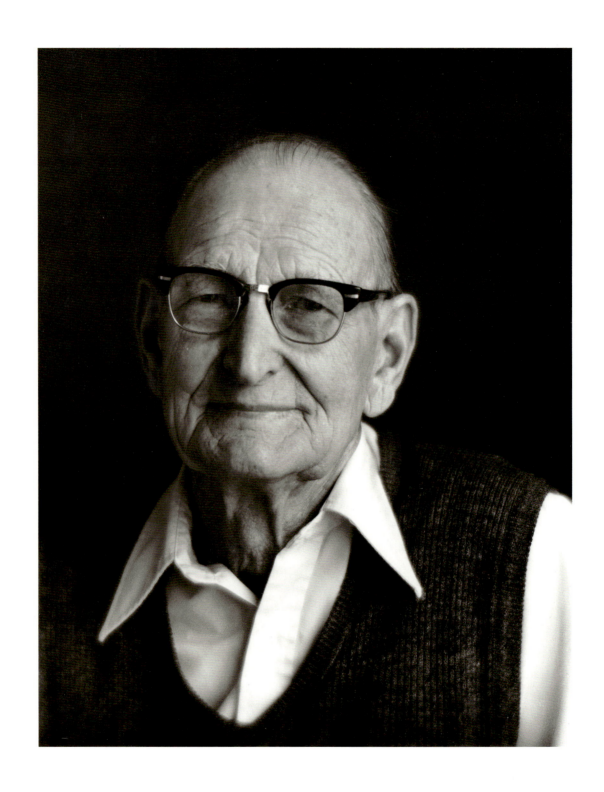

46     *Arthur Gott, preacher, 1990*

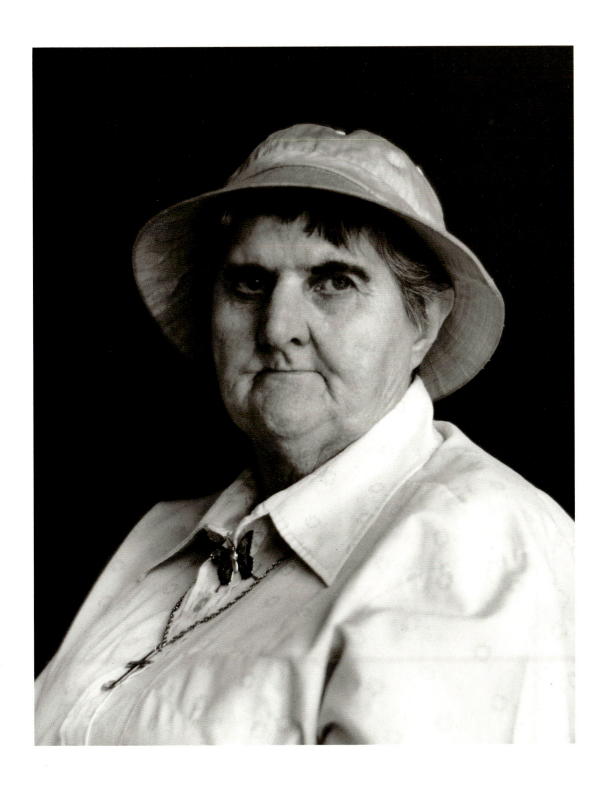

47    *Dorothy Perry, 1990*

# PHOTOGRAPHIC TECHNIQUE: CAMERA AND FILM

TOBA PATO TUCKER

My first portraits were made in 1977 with a medium-format camera, a Hasselblad I purchased second hand, and subsequently used for all my work up until the Heber Springs project.

In 1987 I traveled west to photograph the landscape with a newly acquired 4 x 5 view camera, which I had no intentions of using for making portraits. But I enjoyed using it very much and by the time I arrived in Heber Springs two years later, I decided to put aside the Hasselblad and make my portraits with the larger format camera. The slow and careful process of making a portrait with this time-honored instrument appealed to me, as did the classic shape of the negative, using sheet film versus roll film, and the beauty of the cherry wood and brass of the camera's body.

However, after making the first few portraits of the project with the view camera, I realized how much I missed having eye contact with the person I was photographing at the time that I snap the shutter to expose the negative, and decided to put the camera aside. I needed to find a third camera that had the elements of both the single-reflex camera, which allows me to see my subject before the picture is taken, right side up, and the view camera with its sheet film and deliberate procedures. Was there such a camera?

Through a series of events, I met Greer Lile, a portrait photographer in Little Rock, an expert on large-format view cameras. When I told him about my quest for the kind of camera I describe above, he told me he owned one: a Graflex Super D. Prototypes were popular from the 1930s through the 1950s, the Super D being the last of a long line. He invited me to his studio to see it.

Greer Lile has an amazing studio located in a hangar-like building behind his house, which is also a photography museum. He has a vast collection of vintage cameras of every shape and description representing the history of photography; collections of books and publications related to photography; signed and autographed photographs by noted photographers; and scale models of old-time photographers' studios that he constructed himself with information taken from photos and data. He photographed Disfarmer's

103

studio from the outside in 1961 just prior to its demolition, the last known picture of the old studio.

Greer had the Graflex set up for me to see. For his own work, he had adapted a vintage Kodak 305mm portrait lens to it, first accurately building a bellows of the appropriate size to accommodate the long focal length lens. He recommended this combination to me, understanding what I wished to accomplish visually. (The Graflex is a 4 x 5 single-lens reflex camera; a split second before the shutter is released, while the mirror swings up, the subject is not seen; then the mirror returns and the subject reassuringly reappears.) I looked at the ground glass from the strange apparatus on top of the black box, through the soft focus of the old lens, at the tulle-draped wooden mannequin that Greer had arranged, and was immediately taken. This was the camera and lens I wanted to use for the project.

After extensive communication through the network of antique camera dealers around the country, I purchased the camera and lens Greer had recommended. They were then sent to Professional Camera Repair in New York City where a wizard named Buddy Graves adapted the lens, which he made removable, allowing me use of the original 190mm lens needed for making group photographs. I replaced the antiquated viewing hood with a contemporary one and had it optically corrected for more accurate focusing.

Although the camera was a vintage model, I used a contemporary film—Polaroid's Positive/Negative 55, black-and-white sheet film, for the 4 x 5 format camera. This gave me an instantaneous rough print to preview the exposure, and a negative that was already developed and ready to be used for printing.

The Polaroid film required an immediate sodium sulfite bath after exposing it, removing it from the film holder, and tearing open the film cover. Having my kitchen at hand was very convenient. It was behind a low counter next to the area used for the photographing, and since I was visible, I could have a conversation with my subjects while I processed the negatives after each exposure. Even though I explained what I was doing, only a very few of them showed any curiosity about the procedure.

The studio, darkroom, and living situation in my house worked very well. I appreciated the light streaming in from the glass wall which faced north; it always seemed to be right, regardless of the weather.